Calligraphy Alphabets Made Easy

A Wealth of Lettering Ideas
Margaret Shepherd

THORSONS PUBLISHING GROUP Wellingborough, Northamptonshire

Contents

Using this book	3
Using the master alphabets,	4
guidelines, and special symbols	
Master alphabets	6
Alphabetical index	111

First published in the United Kingdom 1987

Originally published in the United States of America by Perigee Books, part of The Putnam Publishing Group

@ Margaret Shepherd 1986

All rights reserved. No part of this book may be reproduced or transmitted in any form or by any means, electronic or mechanical, including photocopying, recording, or by any information storage and retrieval system, without permission in writing from the Publisher.

British Library Cataloguing in Publication Data

Shepherd, Margaret
Calligraphy alphabets made easy
1. Calligraphy
I. Title
745.6'1 Z43

ISBN 0-7225-1390-9

Printed and bound in Great Britain

Quotation from <u>Speak, Memory</u> by Vladimir Nabokov Used by permission of Mrs. Vera Nabokov.

Special thanks go to Stanley Kugell. Jane Reed, Alison Lewis, David Friend, Jasper Friend, and Zack Friend; and to Maria Kuntz, for her work on paste-up and proofreading

OTHER BOOKS BY MARGARET SHEPHERD BORDERS FOR CALLIGRAPHY
CALLIGRAPHY MADE EASY A BEGINNER'S WORKBOOK CALLIGRAPHY PROJECTS FOR PLEASURE AND PROFIT CAPITALS FOR CALLIGRAPHY
A Sourcebook of Decorative Letters
LEARNING CALLIGRAPHY
B Book of Lettering, Design, and History

10 9 8 7 6

Materials BROAD-EDGED PENS DESIGN ART, NUI, MARY, SANFORD, SPEEDBALL WITH BRAND NAMES OGMIROID, PLATIGNUM, SHAEFFER, KOHIH JO Marken Paint marker Fountain per Metal dip per Witch per Reed per Feather pen Flat brus Flattened penci Notched marke Scroll pen Snub-nosed market Flat round, squar Technical pen FLEXIBLE PENS Crowquill Pointed brus

Fountain boush

USING THIS BOOK

Use this book to sample the hundreds of alphabet styles that the pen puts within your reach. Daily practice is the key to exploring the world of calligraphy; practice new alphabets, review old ones, add individual touches, or invent your own.

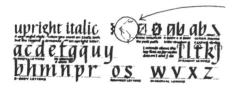

1. Choose the kind of pen shown in the center top line of the alphabet. Most of the alphabets use the broad-edged pen; the rest specify the square, round, or oval monoline pen, or a flexible point. As long as you use the same kind of pen, the size is not crucial—although if you are a beginner, the bigger your practice letter the better!

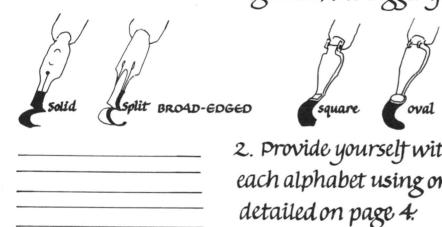

2. Provide yourself with the correct guidelines for each alphabet using one of the two techniques detailed on page 4:

round MONOLINE

3. Holding your pen at the prescribed angle, write each basic stroke at least 25 times — more if you are a beginner or the style is difficult. Practice writing letters in the family groups shown; then try them in words and sentences.

Miss Beverley Delouise 482 Westwood Drive Birchville Indiana 45102 4. Apply your new alphabets to each week's practical project. You'll acheive greater understanding of a new style if you put it to work right away.

Use guidelines when you first try each alphabet. Here are two ways to make them:

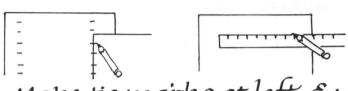

Make tic marks at left & right of sheet, measuring with edge of book page. Connect with ruler & pencil.

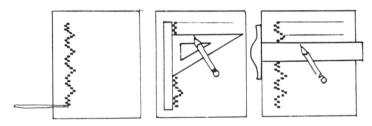

or measure to fit any width of pen by stacking the recommended number of strokes, and draw the guidelines with a T-square or triangle.

USING THE MASTER A

Guidelikes are given for the size of pen pictured. You can vary them if your pen is another width, if you need a largen or smaller letter, or if you want to make the alphabet style heavier on lighter.

Keep pen widt and vary the gi

Keep guidelines the same and vary the pen width.

TITLE often includes alternate letter forms.

GUIDELINE MARKS Help you measure your own quidelines, as described here at left.

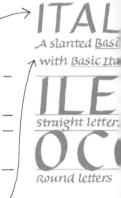

USAGE NOTES are practical pointers abou how to put each alphabet to use-its strength its weaknesses, its idiosyncracies; hints for spacing; other alphabets that derive from o harmonize with this one.

SPECIAL SYMBOLS

LEFTHANDERS'ALPHABETS

This alphabet is suitable for tefthanders.

HABETS AND GUIDELINES

HEIGHT OF LETTER shown in pen widths. Jurn the pen completely sideways and make a short mark; move down to its corner and make another until you have a stack of the prescribed number.

PEN ANGLE differs from style to style, so check your pen position with each new alphabet.

PEN SIZE for guidelines shown.

KIND OF PEN. See Materials (page 2).

LETTER SLANT is expressed in degrees away from vertical.

45° pen angle 30°

BASIC STROKES are the same, or very similar, from letter to letter within a style.

3 (page 38). Use alone or ee36) or Bookitalic (page 74).

same

nes.

Basic strokes

Corner join.

5° letter slant

How strokes overlap

Alternate E Half-round letters, closed open

BASIC JOINS give alphabets their underlying identity.

strokes.

BASIC LETTER BODIES Letters can be grouped in relation to these

shapes plus or minus

LETTER FAMILIES. These practice groups help you see and emphasize the resemblances between related letters. (If letters are shown in alphabetical order, you can look for your own groupings.)

Diagonal letters

LEVEL OF DIFFICULTY

Needs extra practice

Very challenging

ORDER OF STROKES

Construct the letterin this order

DIRECTION OF STROKE

Stroke starts nere and ends here.

Everyone needs a plan for the year. Think about your calligraphic talent; your enthusiasms and failings; the alphabets you love and the styles you dread; & what might give you a shot in the arm (!) if you could only master it. Make a list for the day, 365 alphabets from now, when you size up the progress you've made.

Resolutions						
1.			(.) , " · ·			
2						
3			8		1 24	
4		-				
	5					

Diagonal letters

	40.		
ROMAN	(-)		Meet Overla
Pen angle & letter shape determine groups. Other similarities: M,V;A,W;	Basic strokes	me me	vide Corner edium row joins
Center		12/A.VX	back- wards 20° pen angu
straight narrow letters wide roun	a tetters S Med	aium aiagonai lei	tters 45° pen angle
UDPKF	12 12 U N	IVIVV	3
Half-round letters Med	lium straight letters	Wide diagonal let	tters
		,	
	30°		
letter box	3		Jouch Meet
Mix a square letter body with <u>Basic Gothic</u>	\	Basic strokes	Corner joins
(page 20) to make this geometric style-		••	
G'CMULI	extra A & G	72111	
Basic letter body		ונסכ	Descend ers

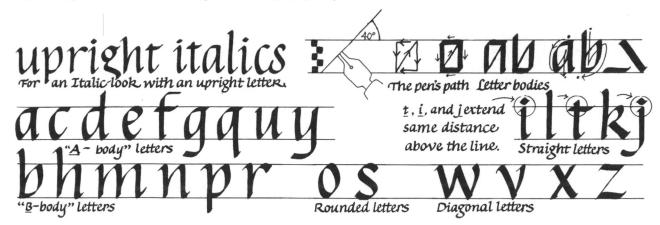

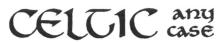

These can be capital or small letters, depending on position, context, & size.

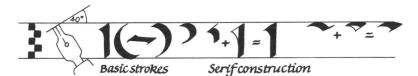

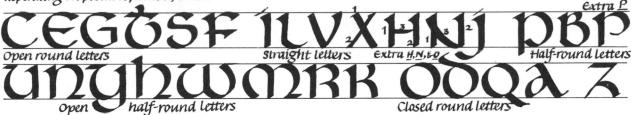

Orthodex Easter Labor Day Independence Day Occoration Day April 9001's Day New year's Eve. Use time off during the year to play with single letters, adapting them to projects & seasons.

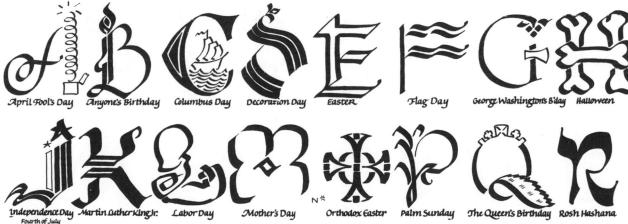

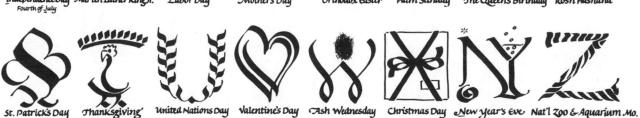

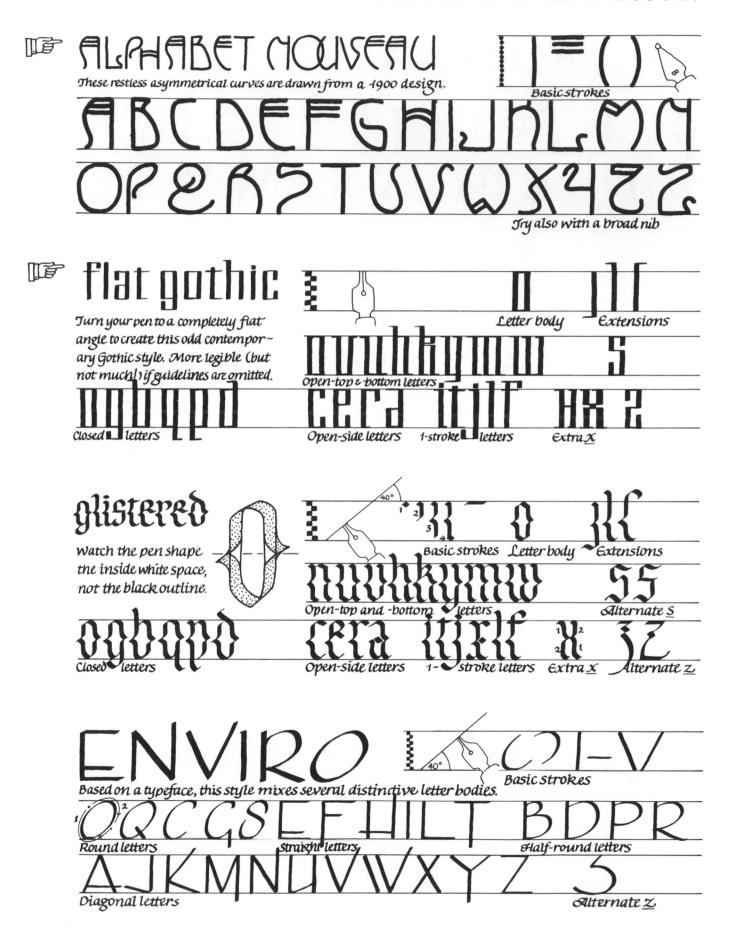

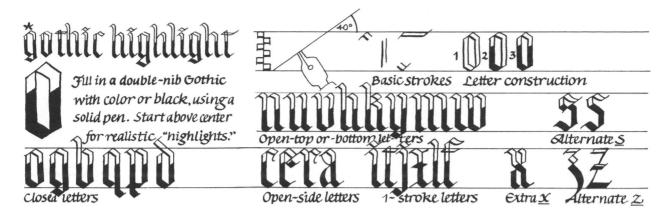

what can you do with a new alphabet every day? Letter all 26, choose a few, choose one. Keep a journal; label a bag lunch; greet your students; post today's agenda; say 'I love you.'

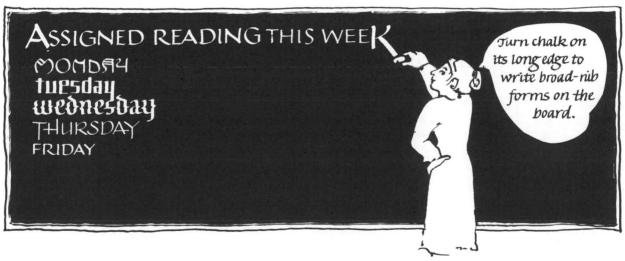

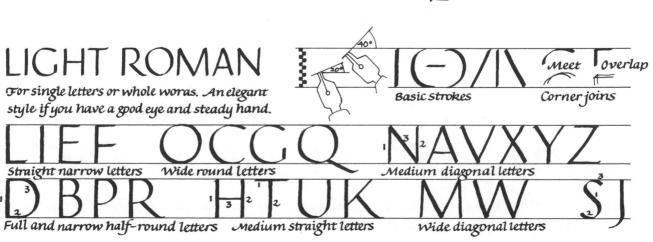

January 14 is Printing Ink Day. To make sure the ink ends up where you want it, letter properly-prepared artwork for reproduction. Use opaque black ink & smooth white. Bristol board* Ceave annie of

smooth white Bristol board. Leave ample margins, where important instructions can be written; don't ever rely on verbal orders. Let your printer instruct you, and remember, "Don't worry about asking stupid questions; they're easier to handle than stupid mistakes."

* or other smooth, heavy paper.

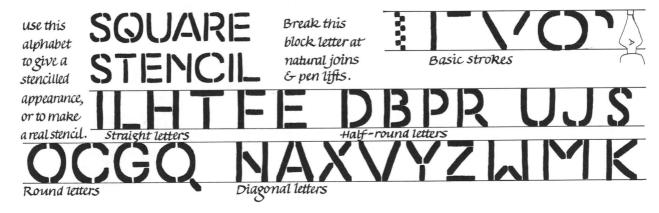

ROMAN

Some printing processes call for a reversed image and lettering.

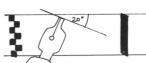

NMLKJIHGFEDCBA ZYXWVUTSROPO

This one will teach you a lot. Reverse each letter as though you had peeled it off the page & turned it over. You'll have to reverse your pen angle, too, to compensate. Check letters by holding up to light.

PARASOL

A simple gray shadow gives an illusion of 3-D.

ABCDEFGHIJKLMN OPQRSTUVWXYZ

Letter gray first if using water-based inks. Or ask your printer to screen an overlay (shown here, 40%).

DRYLAND*

Don't throw away that dried-up marker; create a new version of Neuland (page 105).

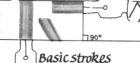

Overlap Overlap Touch

Letters with horizontals (90° pen angle)

Curved and straight combination letters

Diagonal letters

Alternate A

*The title has not been halftoned, to illustrate contrast with the alphabet, which has

PER Copyright Parenthesis Sigma

This way Pounds Exclamation point Pounds sterling

Check Chagrin Question Medicine Paragraph Plus Leo Five Quote

Alphabet of non-letter symbols and type.

Cedilla

Cedilla

Cedilla

Copyright Parenthesis Sigma

This way Pounds Exclamation point Pounds sterling

Check Chagrin Question

Medicine Paragraph Plus Leo

Five Quote

Aries Percent

Letter black on white; specify 'reverse dropout'.

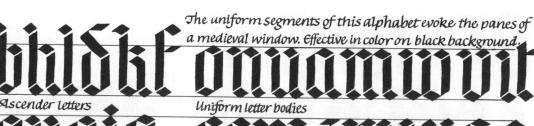

Non-uniform letter bodies and alternates

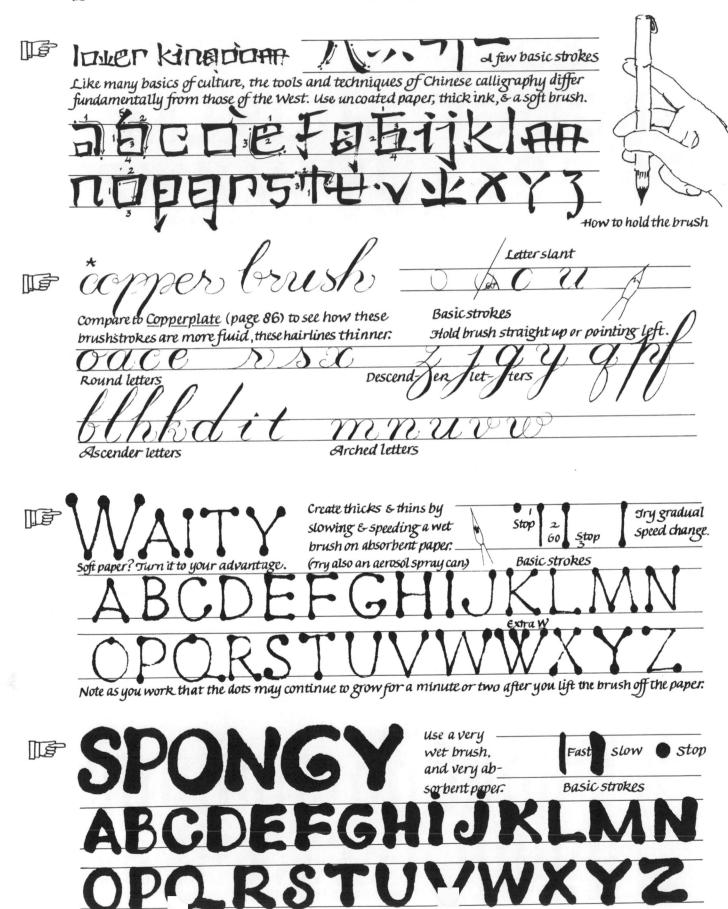

Although Roman letters written with a broad-edged pen have become the standard alphabet of the West, a quarter of the world's calligraphers (a billion Chinese) write with the pointed brush, holding it vertically above the paper. This week, just be fore Chinese New Year, experiment with a tapered brush on a variety of papers, rough, smooth, spongy, or impervious. Hold the handle pointing right, left, or up; keep the brush hairs wet ordry; apply pressure or maintain a hairline; work with deliberateness or speed.

shown here; the characters for 'calligraphy.'

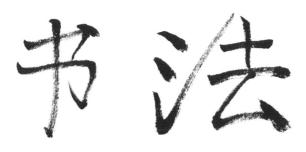

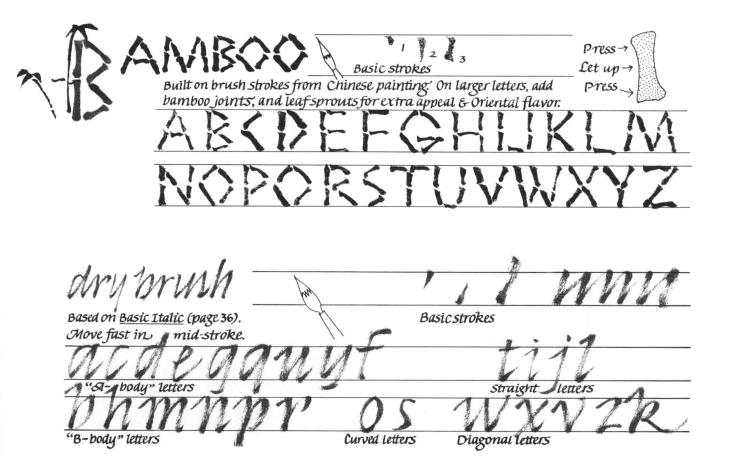

GROUNDFOG

an out-of-focus camera, or 6 less weeks of winter.

LEEHL DBPR UJS

Straight letters

Half-round letters

OCGO NAXVYZWMK

Round letters

Diagonal letters

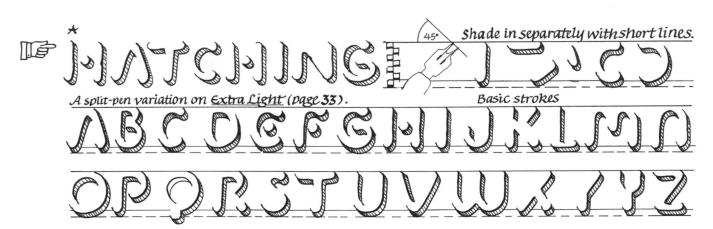

shaded letters give the calligrapher a visual tool of great power, versatility, & grace. Using the broad-edged pen, you can imagine and make a flat, two ~ dimensional letter that casts a shadow, or shape the contours of a solid, three-dimensional one. Experiment with gray and colors, and with the sharp- or fuzzy-edged shadows, as shown here, that signal a six-week difference in winter's length to the traditional groundhog on February 2.

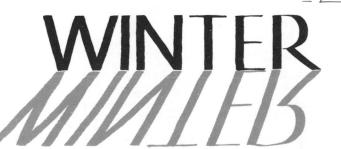

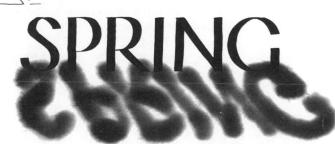

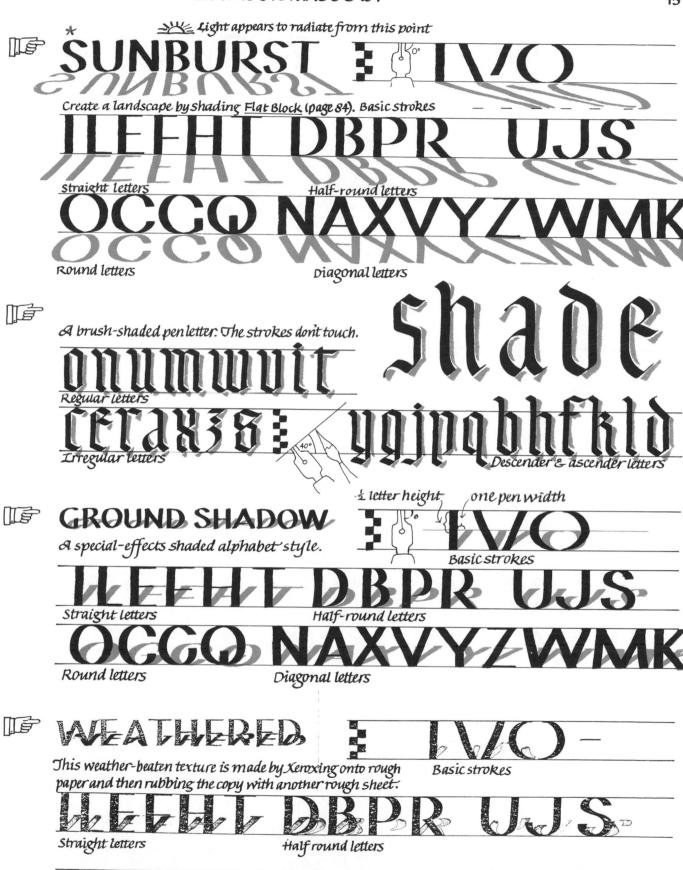

Round letters

Diagonal letters

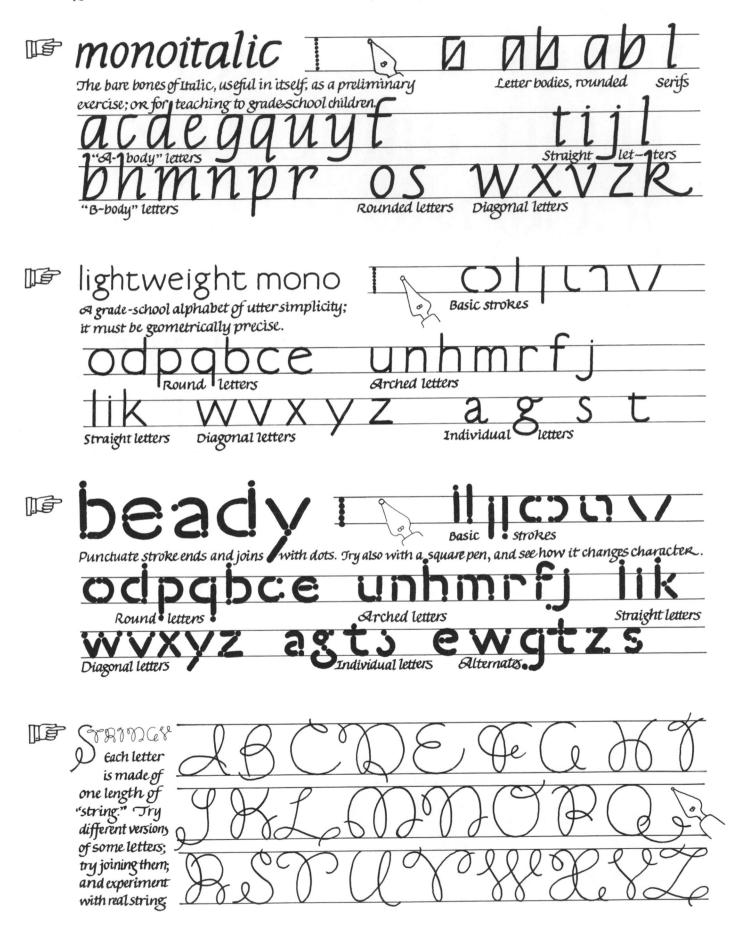

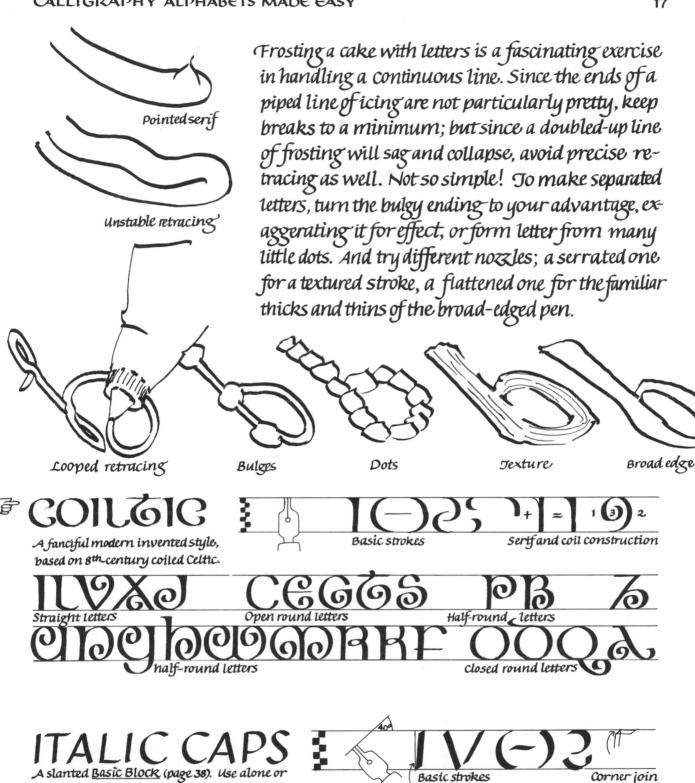

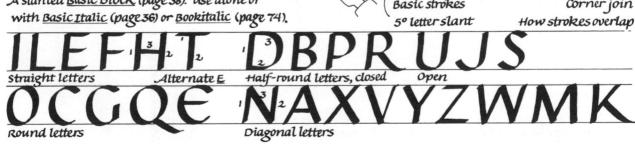

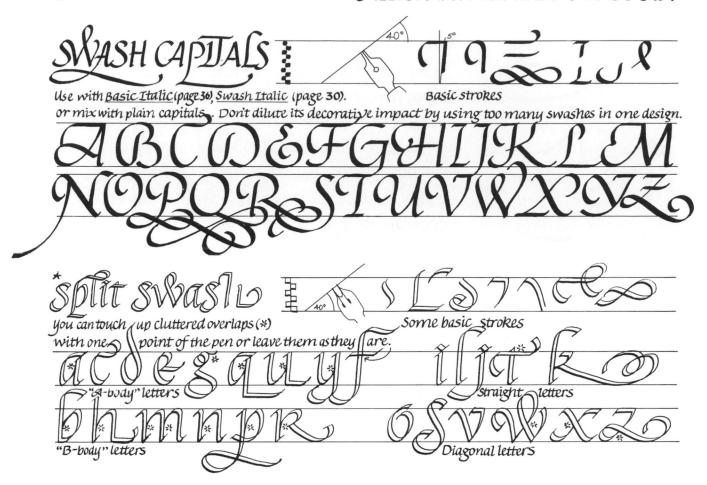

alentine's Day greetings can be sentimental, sensible, sententious, and of course sensational. Even scented!

Just be sure they're sent....

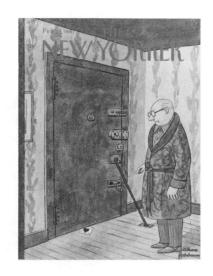

Drawing by Chas. Addams; @1981 The New Yorker Magazine, Inc.

Basic Strokes

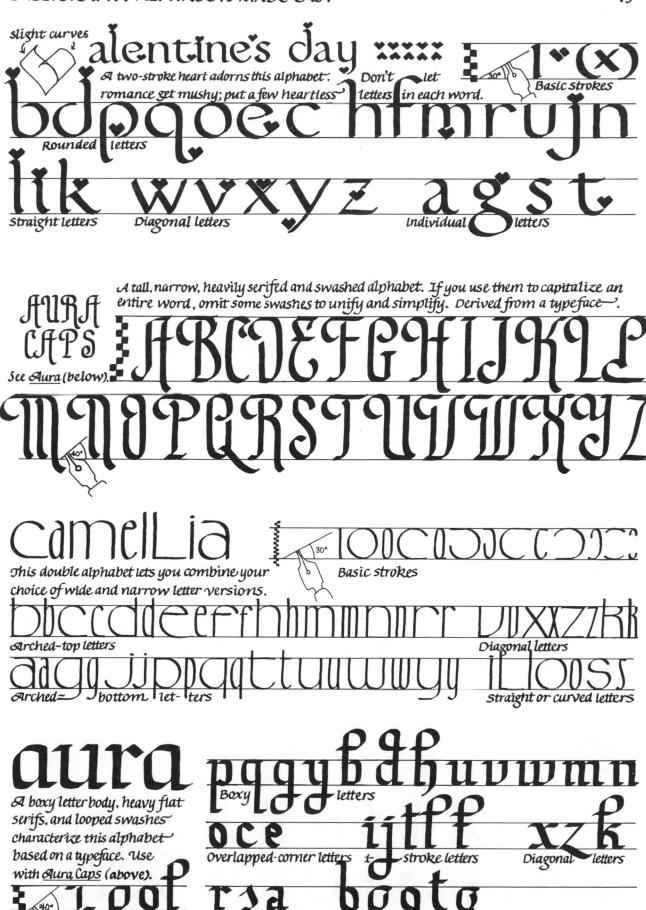

Alternates

Individual letters

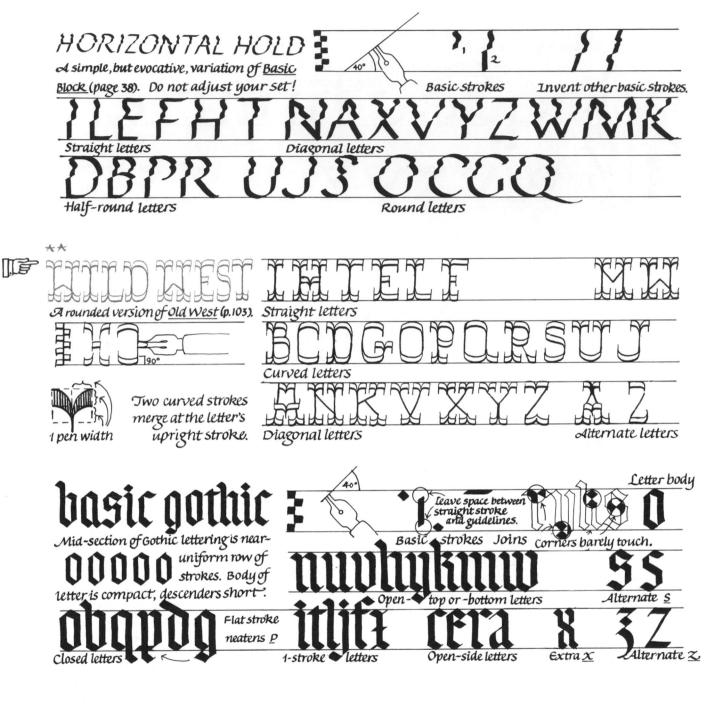

NEW YORKER

Try these urbane capitals on a greeting, poster, or announcement.

* Asterisks indicate letters that, if you can include some of them, strongly establish this alphabet's distinctive graphic identity with a few strokes.

ABCDEF & HJKLMN OPQR*STUVWXXXZ The New Yorker Magazine was founded on February 21, 1925.

Don't let it happen

heavy copy Done with a sharp flexible pen, this was known in the 19th century as a "commercial" hand; i.e., used for everyday business paperwork. IF HEAVY A nice plain (!) Copperplate with a heavy main Basic strokes stroke and a minimum of decorative swashes. CALLIGRAPHER.

Some words are engraved in our collective subconscious; by a combination of alphabet and layout you can work magic on your viewers, slipping a subversive message or visual pun by until they wake up and take a second look.

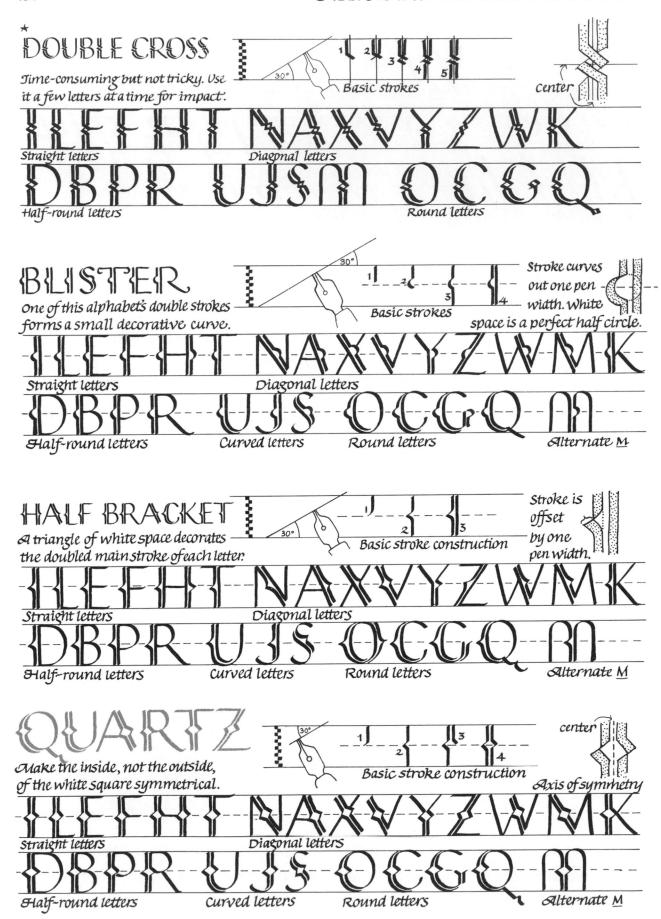

This is Leap Day, added every four years* to make our calendar keep pace with reality. Use the ampersand instead of 'and' (& vice versa) when your line of words threatens to not quite fit the space provided. The difference between the width of and and the ampersand can sometimes decide you in favor of an & Of course, ampersands can also just adorn the year 2000.

During a Leap year, adjust dates mentioned after March 1 by subtracting 1.

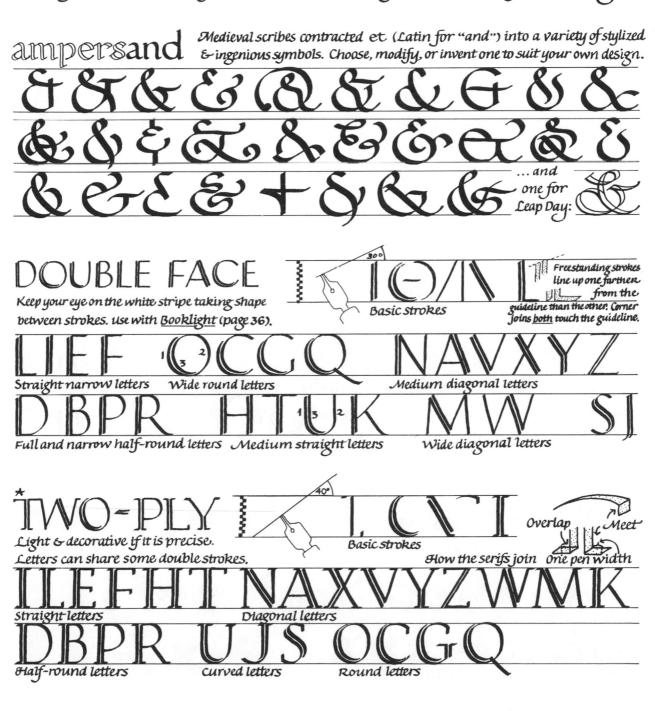

The first week of March is Procrastination Week, when many people decide they will put off losing weight. Celebrate with a banquet of heavy letters, and experiment with fat versions of your regular alphabet styles. But inside every fat letter is a thin letter trying to get out—the imaginary pathway the pen follows. Keep your minds eye on this & on interior white spaces.

The pen's path

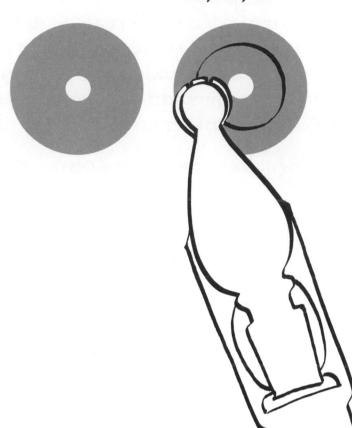

FAT SHADOW

A nice fat, solid, plain, dependable alphabet that also casts a substantial letter shadow.

ABCDEFGHIJKLM NOPQRSTUVWXYZ

fattest mono

sa letter with a weight problem; take great care to keep the tiny center space uniform.

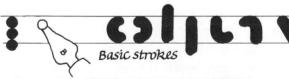

odpabse

Unhmrfj Arched letters

Arched letter

Straight letters

Diagonal letter

Individual letters

Gybo

An extremely heavy Neuland (page 105). Try other solutions to the E problem. Basic strokes Overlap Overlap Touch

Curved and straight combination letters

Alternates

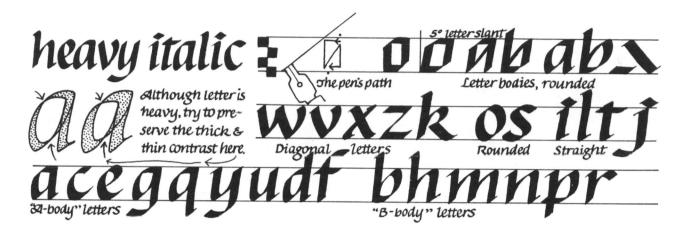

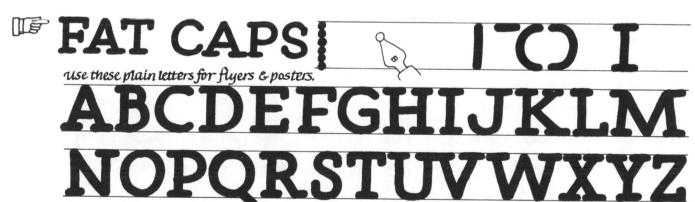

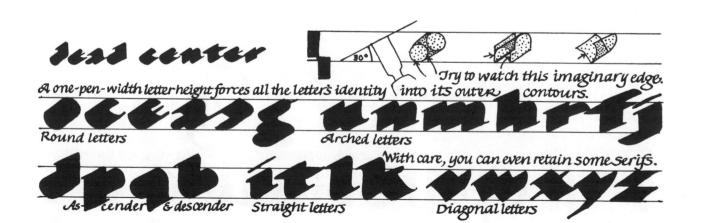

Basic stroke

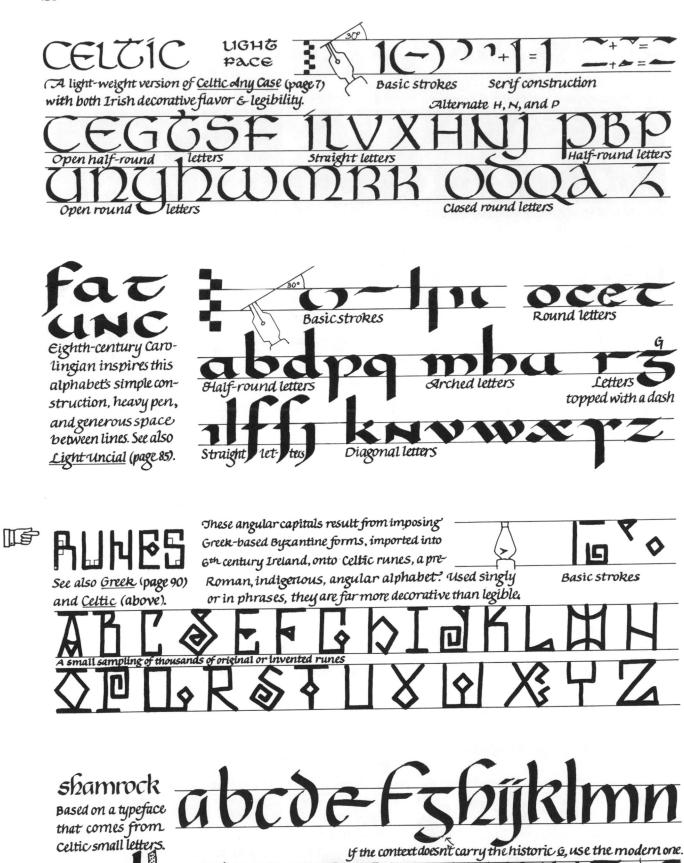

SHAMROCK CAP Adapted from a typeface, this graceful style can be used on its own or with shamrock small letters (page 26). HODGE GHOWN OF WITH Shamrock Small letters (page 26). Slight curve

Stretch these letters to fill the end of a line, elaborate one for an initial, or just fiddle in a spirit of experimentation.

Stretch these letters to fill the end of a line, elaborate one for an initial, or just fiddle in a spirit of experimentation.

Stretch these letters to fill the end of a line, elaborate one for an initial, or just fiddle in a spirit of experimentation.

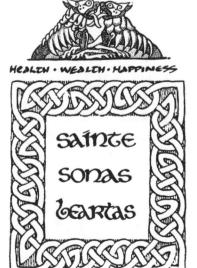

(II) ISH SOMEONE A HAPPY ST PATRICK'S DAY WITH AN IRISH GREETING, CELTIC LETTERS, & A BIT OF DECORATIVE BORDER FROM THE BOOK OF KELLS, ALL HELD TOGETHER WITH A COLOR SCHEME OF GREEN AND GOLD.

This may be the method | Arch one space | Break and rejoin | Form band | Remove of the Pictist artist. | above and below | in various ways. | Form band | Centre line | under, alternately.

Use India Ink or waterproof marker to draw the border so that the filled-in color won't make the outline run. The borders here are from <u>Celtic Strt: The Methods of Construction</u> by George Bain (Dover).

when you make placecards for a large dinner or one where people may not be sure of each others' names, help them out; letter the names twice, on back and front of the card, so others can see name instead

of asking—or wondering!
Reanor Bolen
This idiosyncratic alphabet combines several distinctive letter bodies and serifs. Use with Gastern Capitals (below). OOCOGOUY Round letters Diagonal letters Individual letters Straight letters
EASTERN CAPITALS Based on a typeface called Park Avenue; use tnem, sparingly, with East Side small letters (above). Basic strokes with pen pressure with pen pressure.

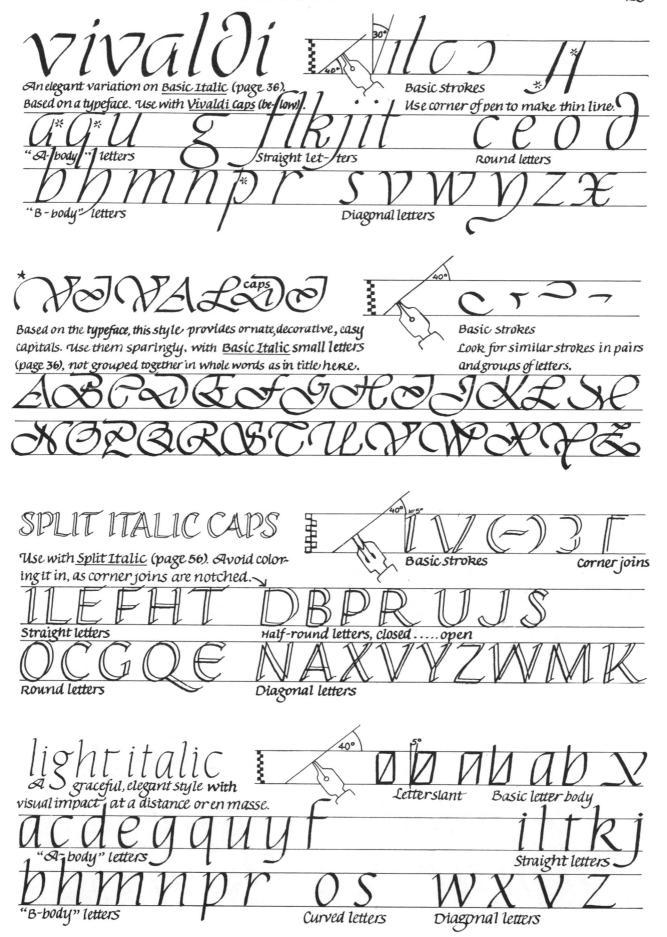

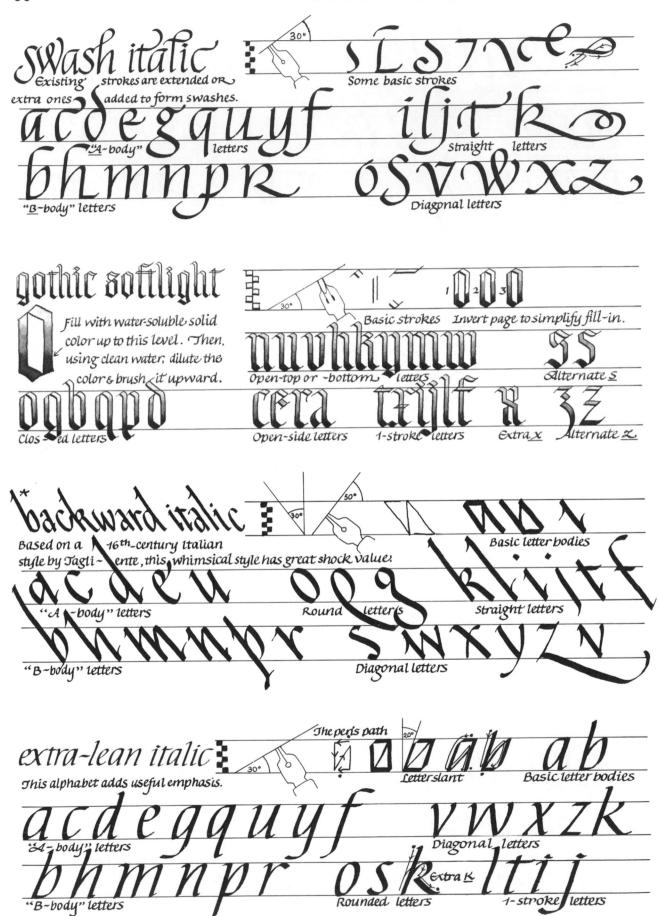

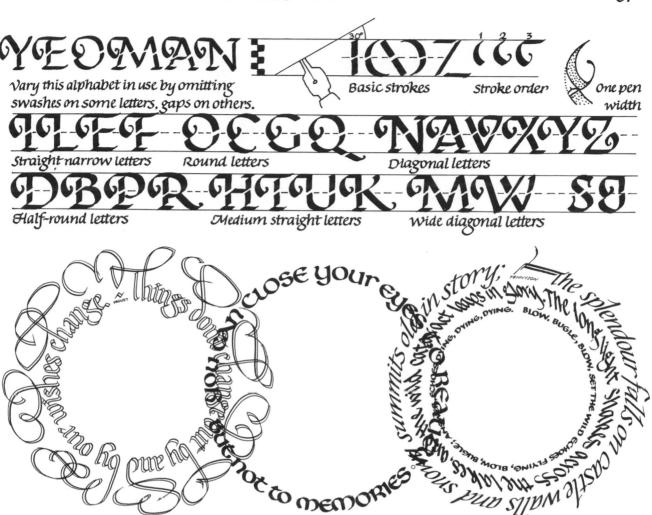

Lettering in a circle; an appealing layout that challenges both calligrapher and reader: Three approaches are shown here, overlapped to save space; split in two for easier legibility, swashed for decorativeness, and slanted for abstract visual impact. Use compass, protracter, circle template, & straightedge for guidelines.

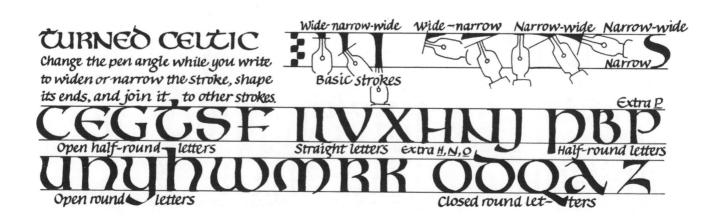

use a punctuation mark instead of a letter, to put your point across with extra punch and humor on April Fools Day.

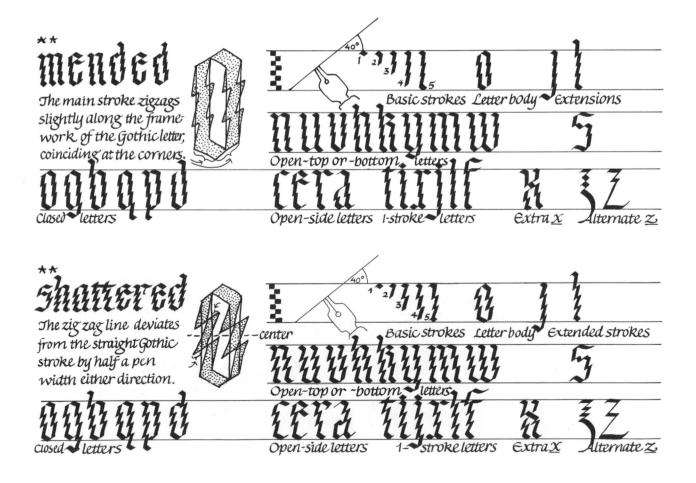

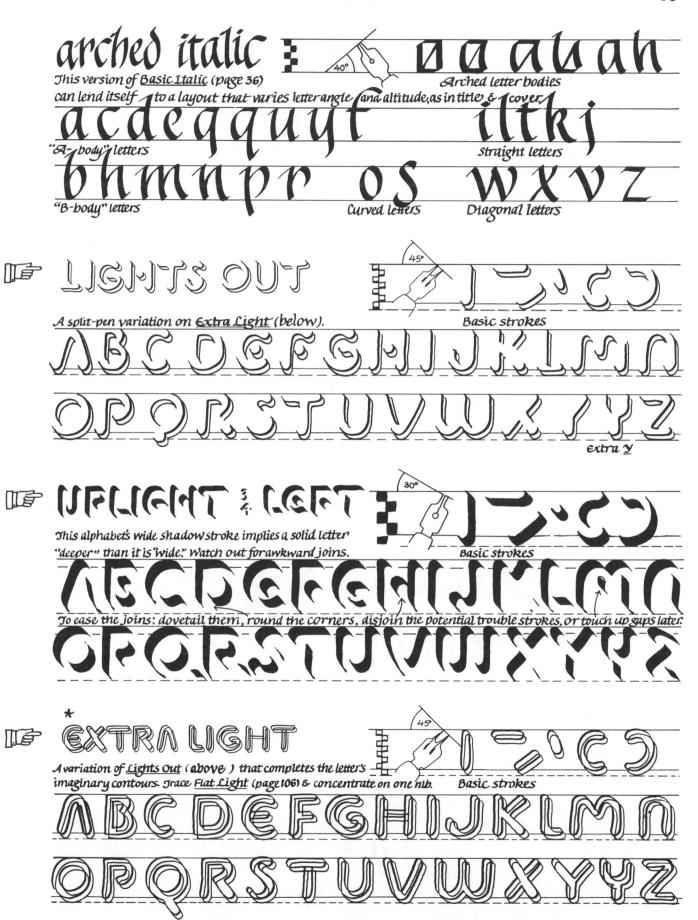

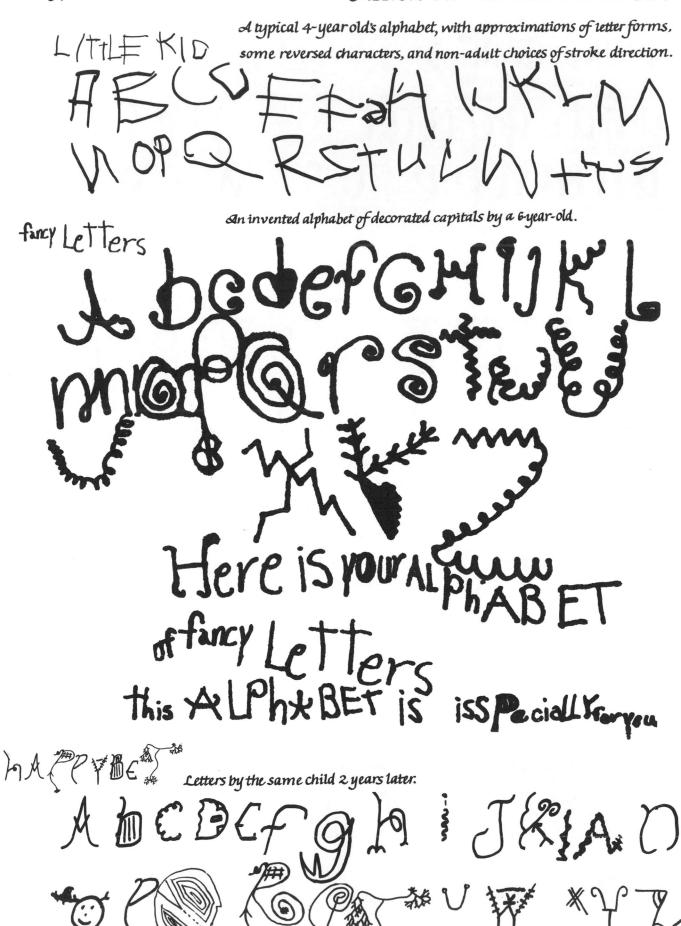

BIG KID A BCDEFGHIJKL MNO PORSTUVW X Y Z Print official grade-school letters by an 8-year-old. Obcole Ghijk Imnop9 LEMONADE Interest insulad youadopta. Kd? Tohone fun. Teccetteec the Import

a logic and charm all its own. It's hard to improve on and harder still to imitate. If you want to write like a child, construct each letter in reverse, to see it anew. (Use kids' materials: crayons, newsprint, scissors, paste, construction paper, poster paints.)

Remember those loops? Write elegant

Copperplate (page 86) with a monoline pen, and what you get is plain everyday Palmer:

Round letters

Individual letters

Olders: Round and straight

Ascenders: Round and straight

Arched letters

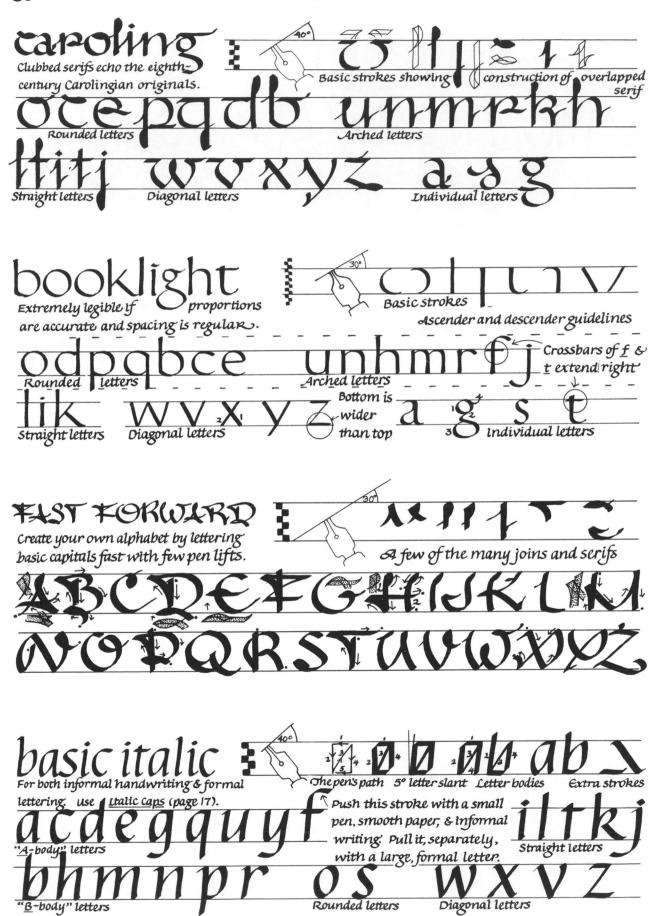

Lettering a long piece of text? Not 10 lines long. 10 hours long; a memorial book, a mammoth one-page declaration in small print, an ambitious artistic project of great visual complexity and scale. In any case, you must train, warm up, and pace yourself for it. Choose your equipment carefully, to preclude glaring discontinuities. Wiggle your fingers—and your back—every 15 minutes. Above all, check and recheck constantly to guard against the disastrous hidden error that could render all your work in vain: the single mis-ruled guide—line; the omitted or repeated phrase; the wet pen dropped on the next-to-last line. Take courage from other long-distance artists toiling along the Boston Marathon on Patriots Day this week.

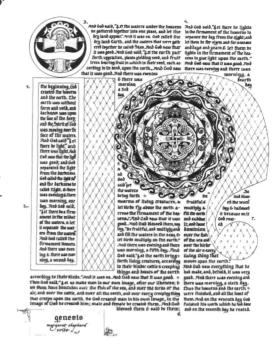

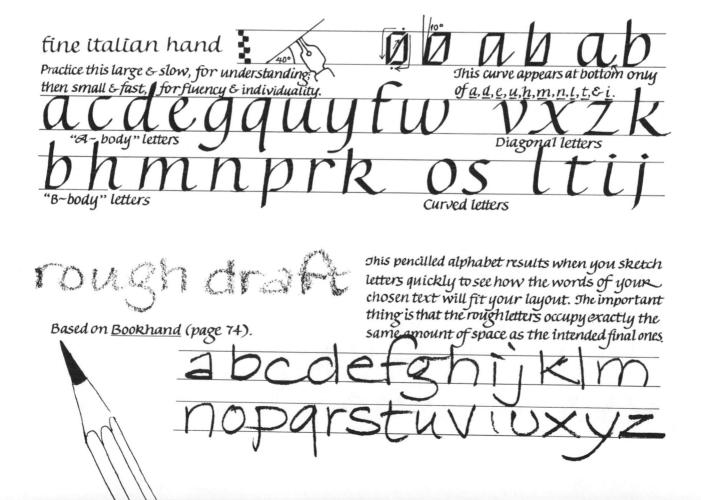

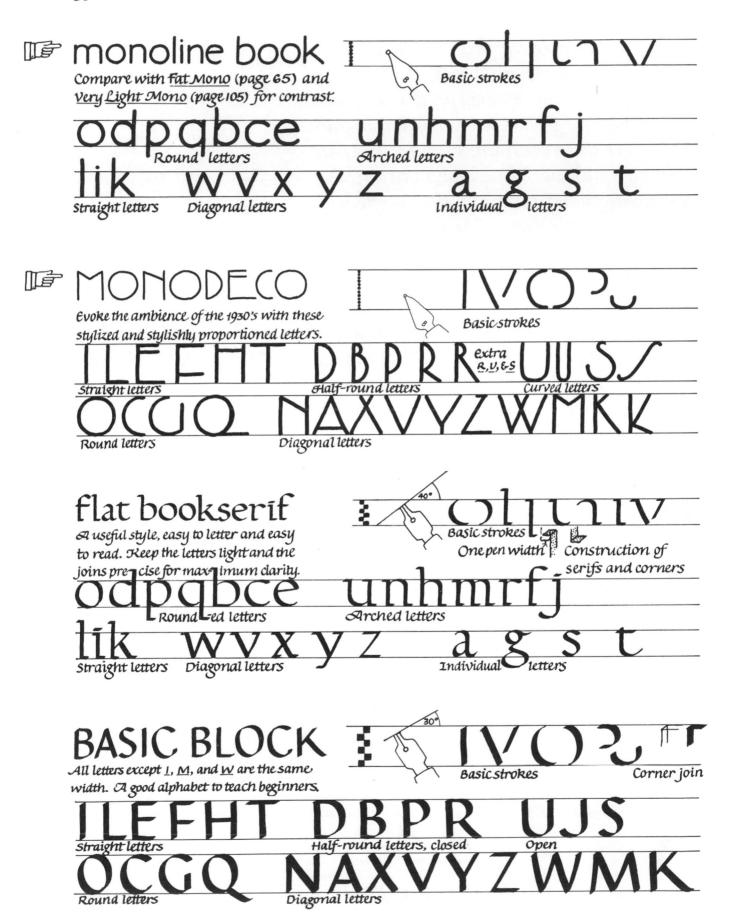

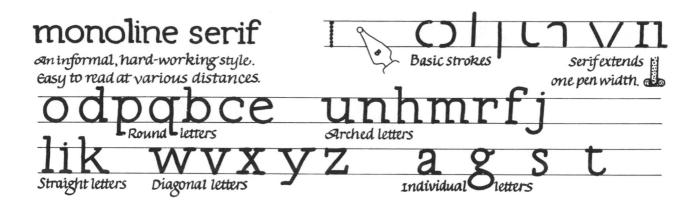

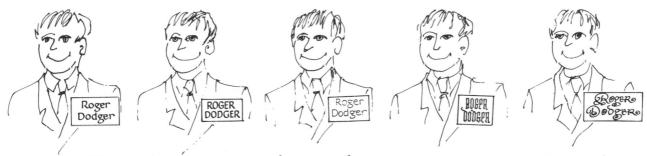

some calligraphy projects demand that you consider legibility above all else. A name tag will be almost useless if people can not read it at a glance while shaking hands. Remember, as you choose a letter style for name tags, that lightweight, unusual, or ornate alphabets make names harder to read, and that words in all-capitals are less legible than the usual capitals and small letters.

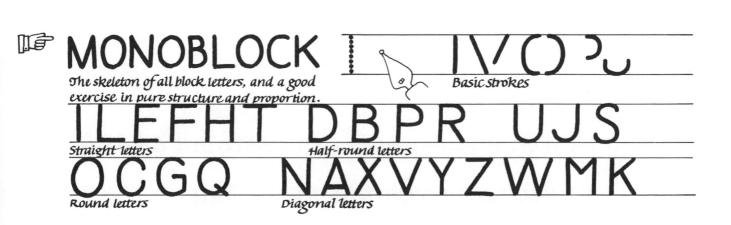

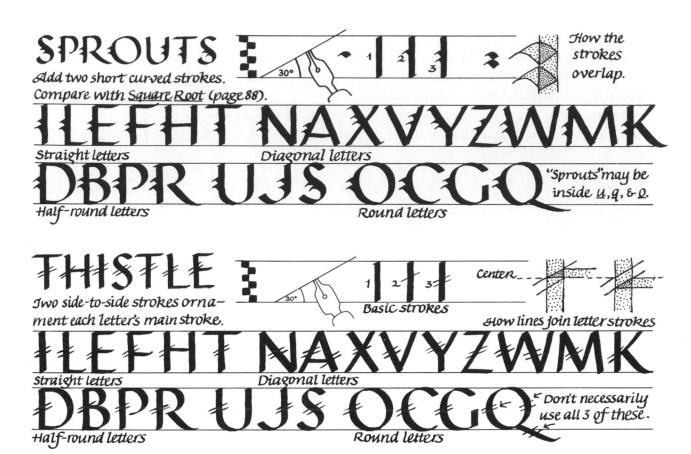

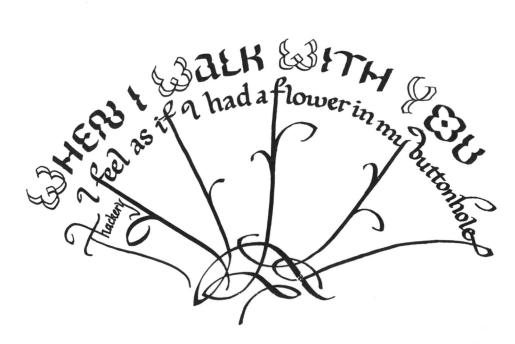

Wear a flower, give a nosegay, or write out a whole bouquet to celebrate May Day.

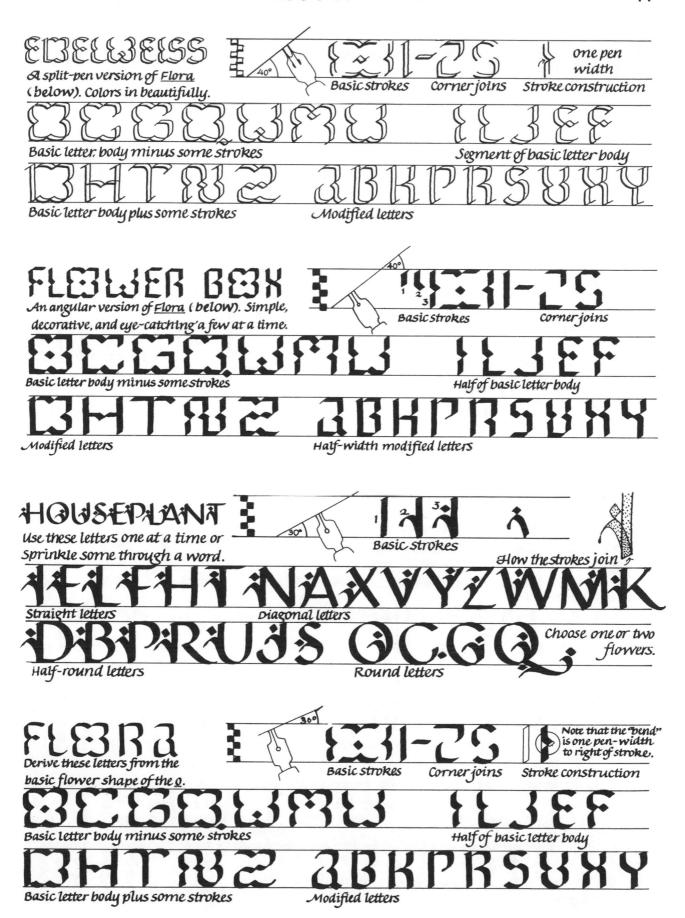

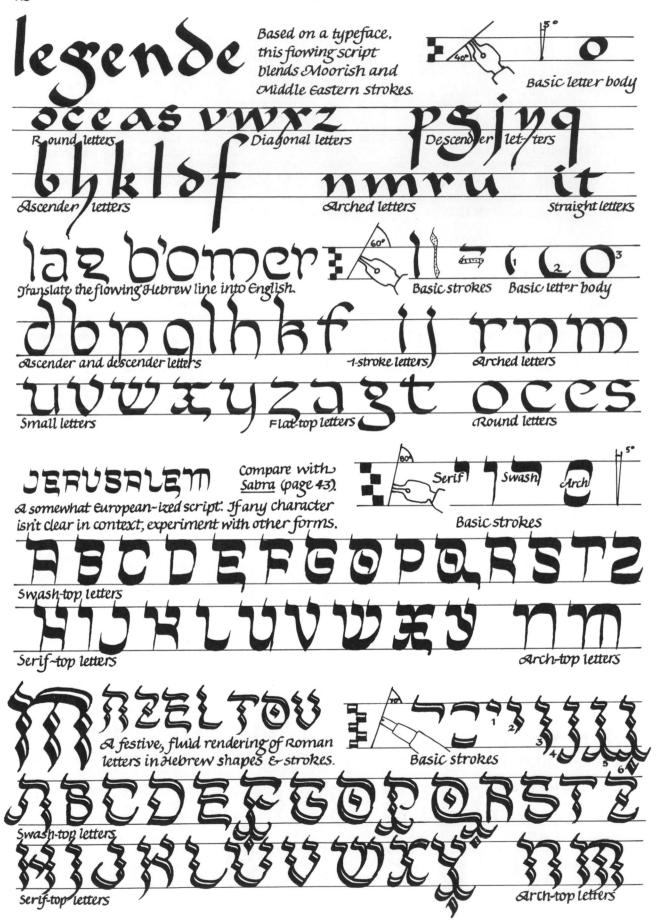

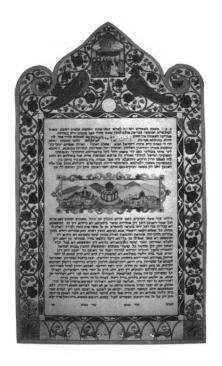

Jewish marriages were traditionally documented with a marriage license called a Ketubah. This certificate, now a semi-official option, can be adapted to the spirit of all religions. Its lush ornament is personalized with colors & motifs that reflect the individuality of the betrothed couple. Framed and hung over the marriage bed, it makes an incomparable wedding present and a priceless heirloom for future generations. The second week in May is Jewish Heritage Week.

& squared-off, chunky style that shows the adaptability of the Hebrew idiom.

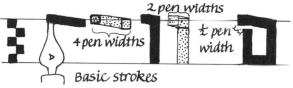

Serif-top letters Flat-top letters

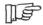

Pen angle & letter angle are identical.

stroke

A very non-European alphabet; with a backward letter slant and a distinctive pen angle. (Curl hand around.) Basic strokes

Height to width proportion=线

swash-top letters

Serif-top letters

Arch-top letters

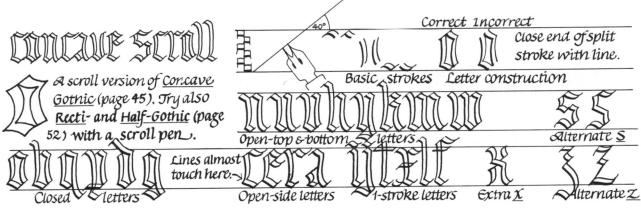

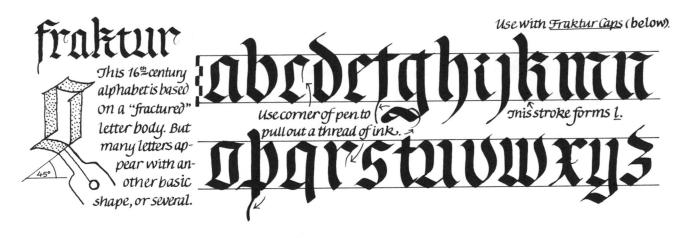

Restless strokes & fluid, forceful swashes form these ornate capitals. Don't let the line get toosweet & soft. Use with Fraktur (above)

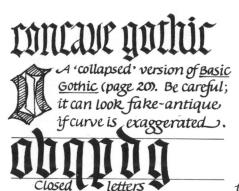

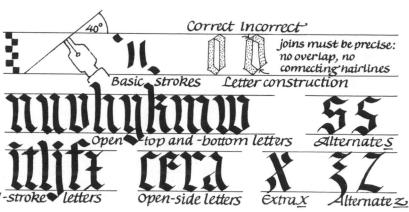

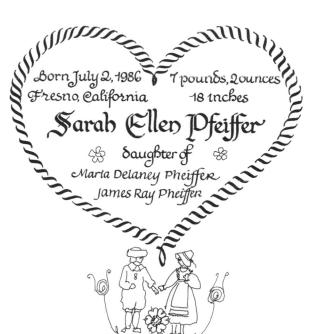

Did you know that babies born in May are on the average 200 grams (4 pound) heavier than those born in other months? Celebrate any new arrival with a 'fraktur,' the folk-art birth certificate originated by 19th-century Pennsylvania Dutch. Include name, parents, aate, and place, and decorate with naive flowers, quaint people, and ornamental pen flourishes.

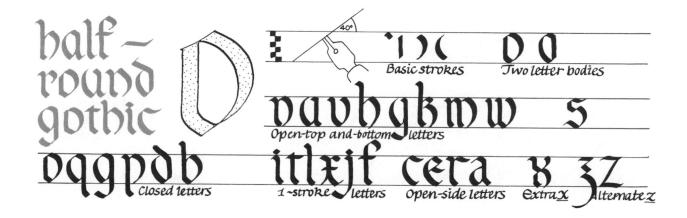

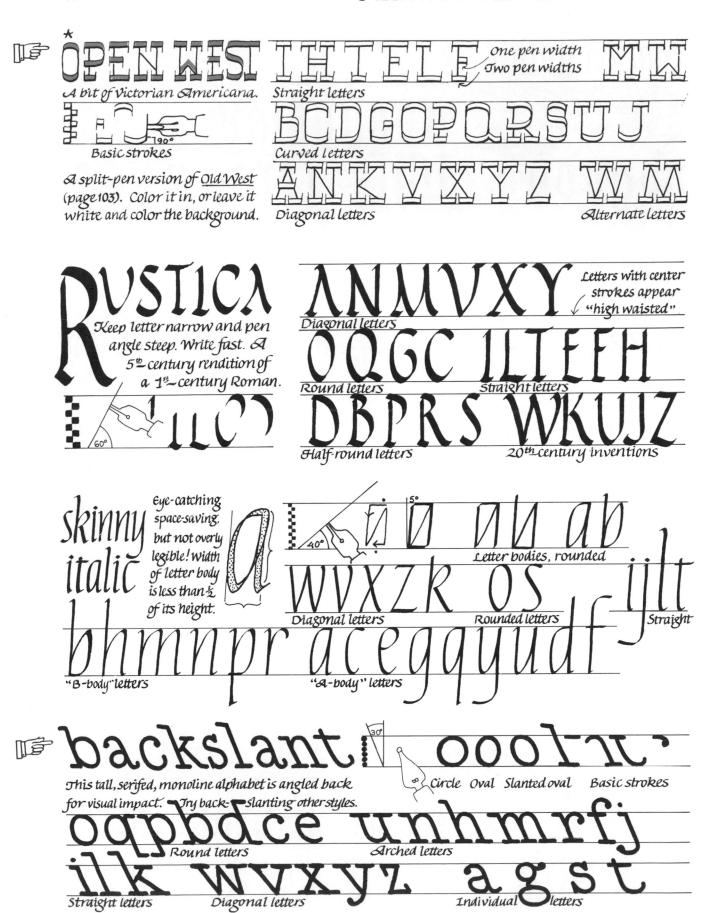

chancellaresca	This alphabet, based on a type fa	ce, is a combination of
	Copperplate and Italic, with na	irrow pen & steep slant.
oace sz	$\mathcal{X}I = GII$	Da Uso
Round letters Individual le	etters Four differ- ent d	escenders
30°		
Dankly	5 mn	UVWT
o4scenders //	≪rched letters	
carpetbags	£ 30°	UNOG
This alphabet manages to harmonize half a	Ascenders are 3 times the	Practice joining this
dozen families, ascenders & descenders of	letter body height; descenders	letter body smoothly
different heights, and other minor quirks.	are shorter than one.	to the straight stem.
101	an establica tritari orte.	w the strught stem.
	11111 (11)(1	12 (A (A
Arched letters	Tear-drop lett	ers)
ITKILOCE	WVXZ	trs
Straight Sletters Round letters	Diagonal letters	Individual letters

May is 'Correct Posture Month'. Help your letters' all maintain one letter angle, as almost every alphabet style* relies on a uniform letter angle. Your eye will usually detect the one odd drunk in a crowd of teetotalers; it's the gradually-leaning row of degenerates—or the ones pitched at the wrong angle to start with—that sneak past you to disorient the viewer. Some precautions against wry angles: rule occasional pencilled verticals (or near-verticals) in addition to horizontal guidelines, for a visual reminder. Reorient your body and hand to the paper to help your eye maintain a constant letter angle. To check uniformity, hold paper on palms, almost edgewise to your eyes, and squint.

^{*}But see <u>y-chromosome</u> and <u>Arched Italic.</u> (pages 49 and 33)

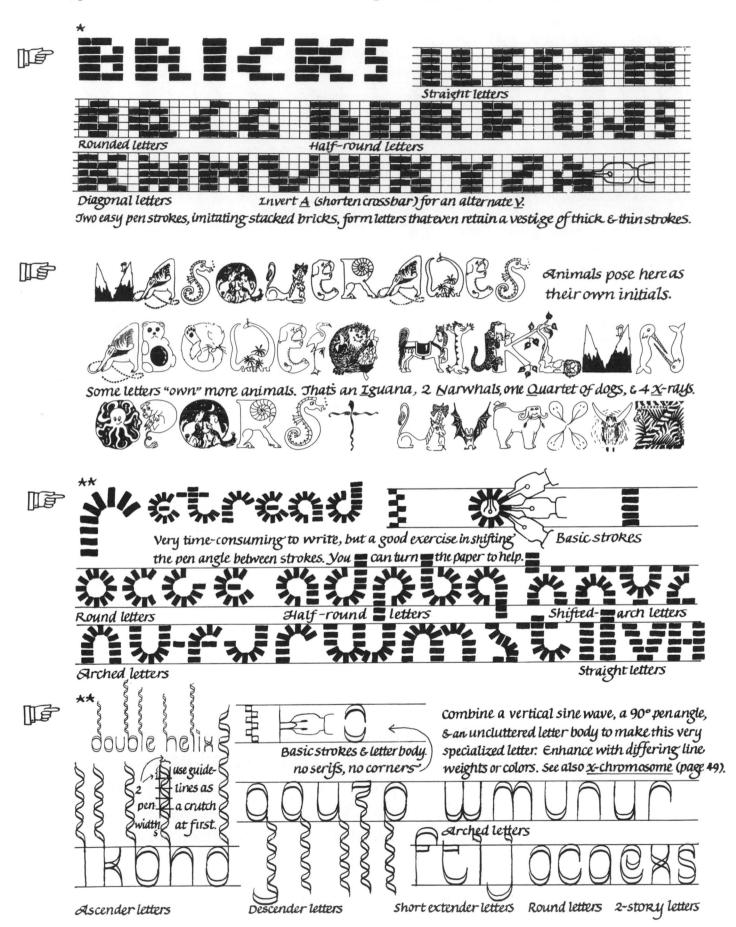

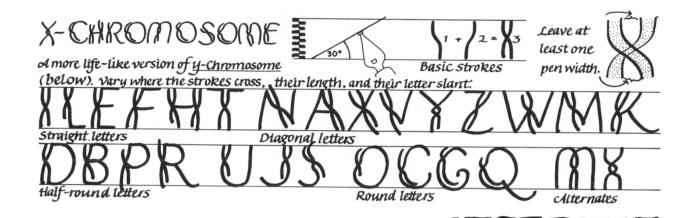

Medieval bestiaries collected real and mythical animals, and ornamental beasts filled illuminated manuscripts. During National Zoo Month, use animals and real objects to decorate, inhabit, or impersonate the letters of the alphabet.

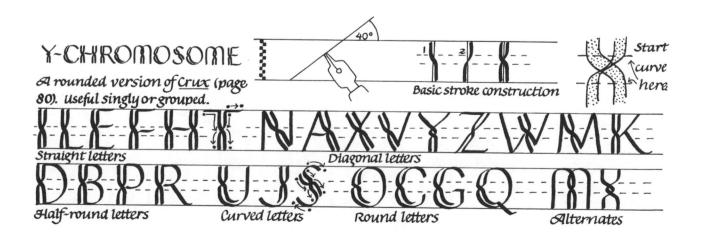

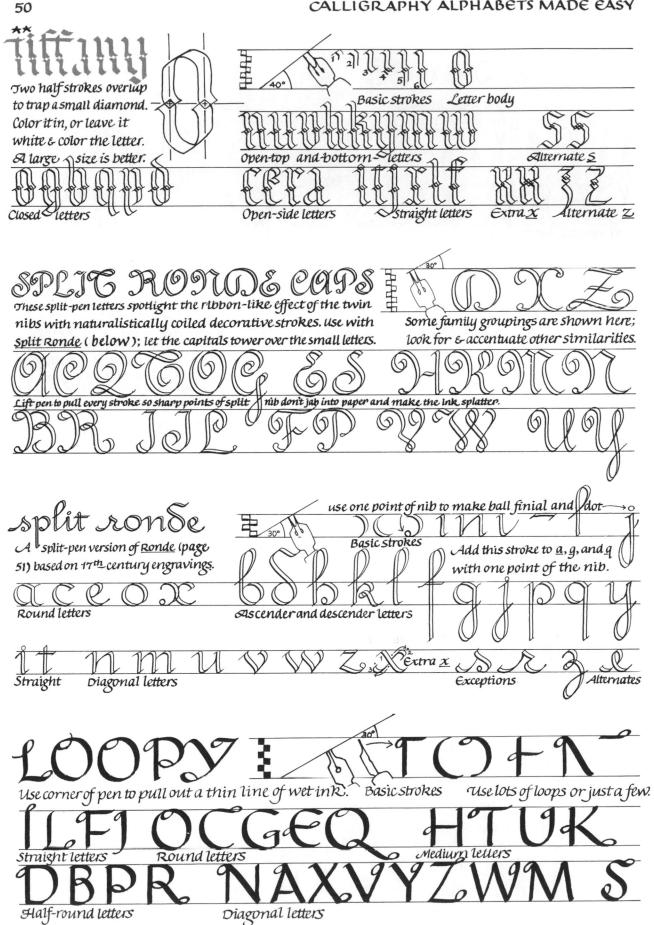

Cathie Dobson and Jake Wheeler
would like you to join family and friends
for their wedding
Saturday the second of June at three o'clock
Milton Academy Chapel
Milton, Massachusetts

and for a reception at the home of her parents

Jr.S.V.P.

Mr. and Mrs. John Gordon Dobson

118 Needham Avenue

Dedham Massachusetts 22 22 6

lettering for the formal invitation to a June wedding (even though more couples, in fact, marry in the month of December!). A few—less than three—simple swashes add warmth without detracting from the effect of elegance, solemnity, and joy.

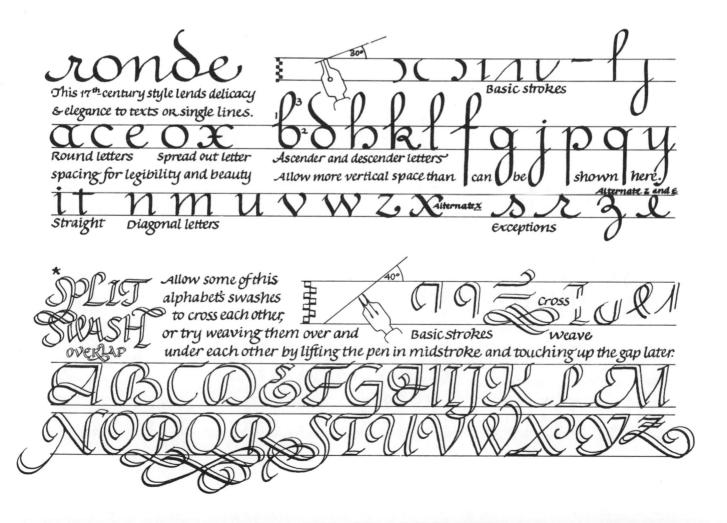

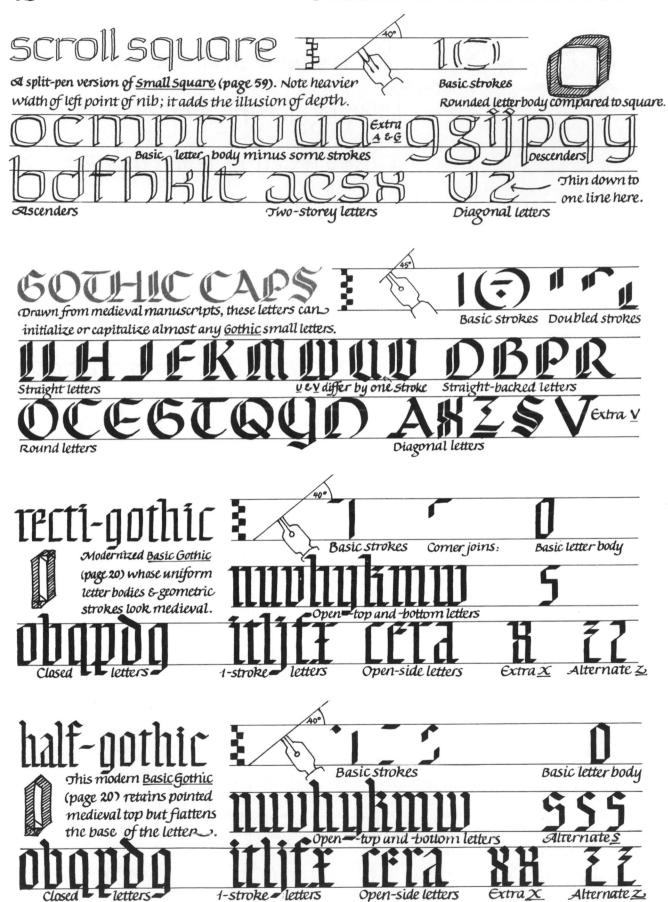

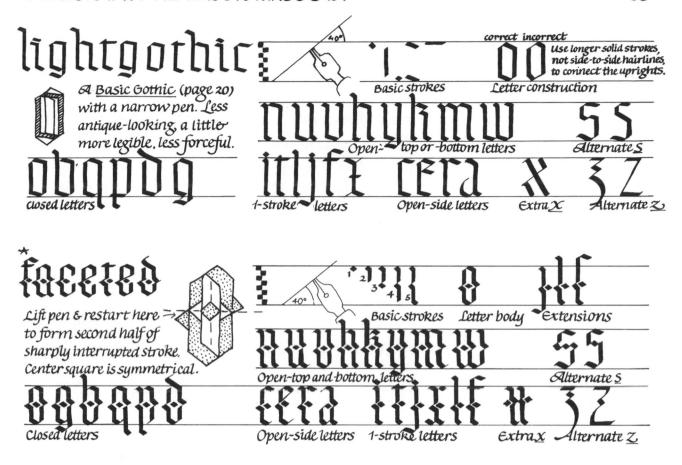

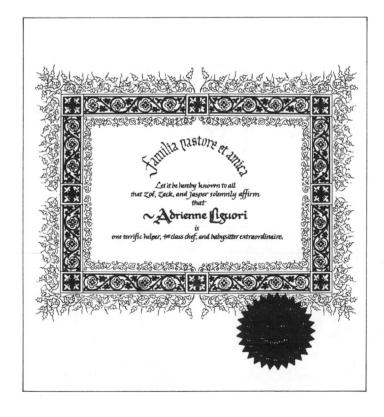

Not every diploma has to come from an institution, nor go to a graduating senion. Reward someone for everyday tenacity or extraordinary virtue with a 'diploma' of your own creation that resembles the real thing:

cMiss Beverley Delouise 482 Westwood Drive Birchville Indiana 45102

Miss Beverley Delouise 482 Westwood Drive Birchville Indiana 45102 When addressing envelopes, choose from either a flat-left or a slanted-left style of layout. Plan pen size, letter size, spacing & line placement by lettering several rough drafts of the longest name and address on your list: for example, Mr. and Mrs. Francis Belmont Smithson, 13286 Columbia Point Gardens, #14R, East Hampton, Massachusetts 02345, not Gail Ely, 2 Main Street, Ames, lowa 50123. And when you choose an alphabet, be prepared to see a lot of that capital 'M,' which initializes most of the formal titles that you will be lettering

Mr. Mr. Alt. Mr. Mrs. Mrs. Mrs. Miss Miss

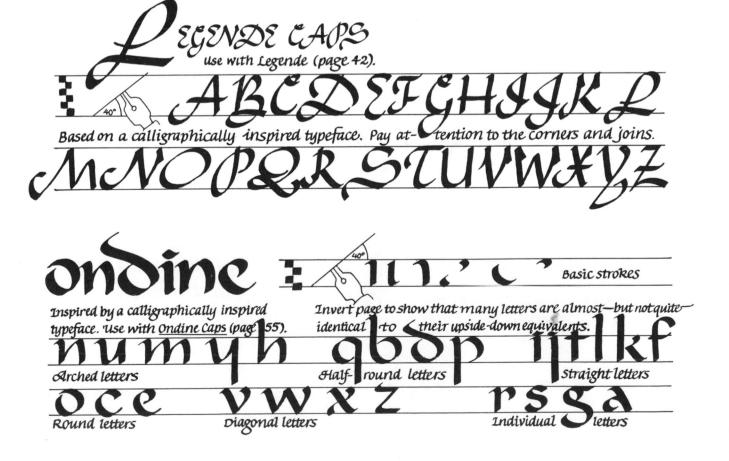

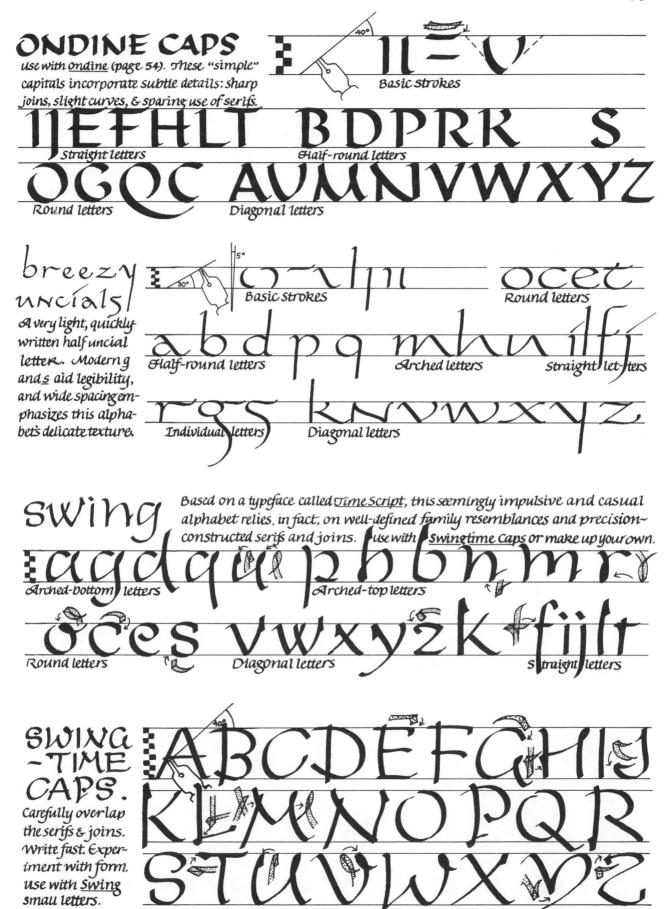

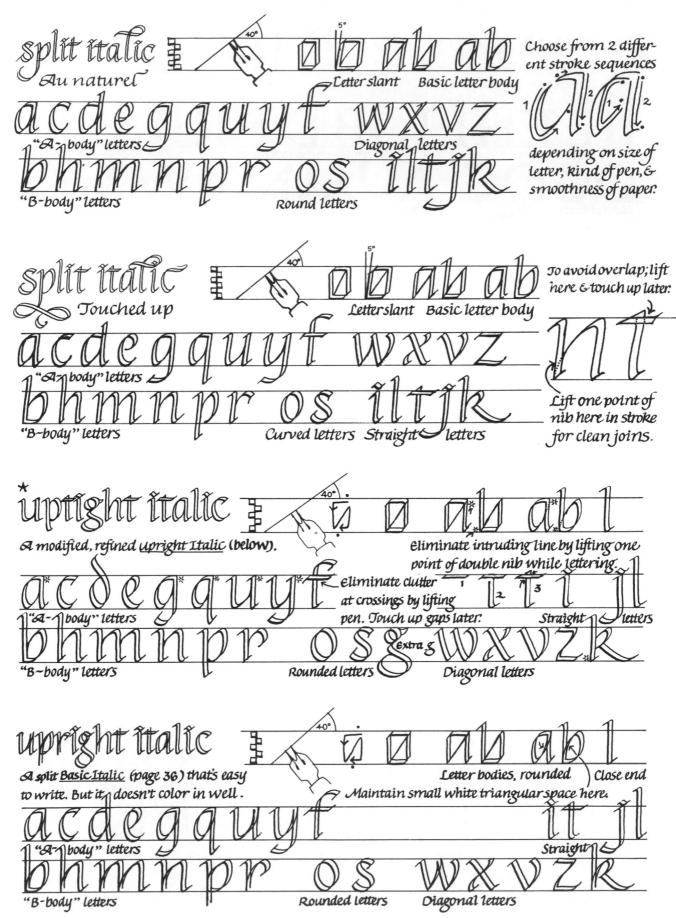

June 30 is, along with December 31, the day when the Bureau International de l'Heure can determine to add or subtract an extra second to ensure that man-made clocks will coordinate with astronomical time. A'Leap Second' is added every year or 2. If you think such small quantities don't really matter, watch this: If you think such small quantities don't really matter, watch this:

just .1 mm ($\frac{3}{1000}$ inch) of space less between letters and you end up with a noticeable gap at the margin. Think of the difference those accumulated missing seconds might make in 1000 years!

3 slightly different split-pen letters. A delicate and graceful style, if you take Letter bodies, rounded Close ends care to avoid (overlapping at the corners. 1 body "letters Straights letters1 'B-body" letters Rounded letters Diagonal letters o not let arch push into stroke Be careful that the outlines Use one point of the split pen to close stroke and tidy up the join with great accuracy. of the narrow stroke don't touch. Round letters Diagonal letters Straight letters Individual

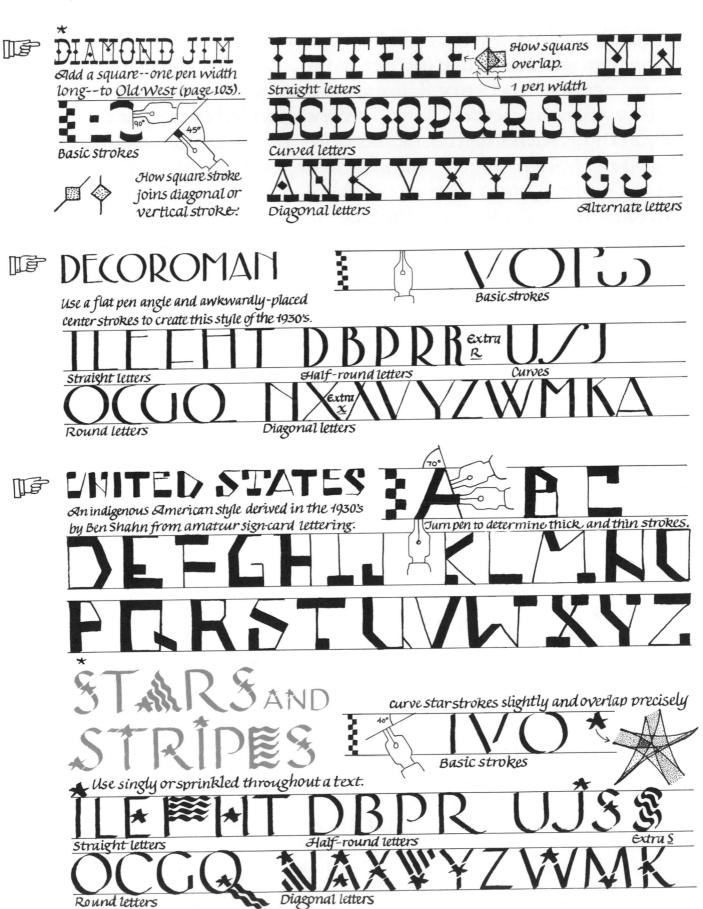

Free from English rule and far from European fashions, Americans developed their own idiom in the arts. The distinctively New World alphabets of the last hundred years are chronicaled here to show how over the years our national taste grew and changed.

Independence INDEPENDENCE

Independence

INDEPENDENCE!

INDEPENDENCE

INDEPENDENCE

DNDESENDENCES (

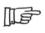

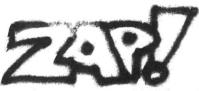

an informal, flexible, personal alphabet for posters and displays, or a street-smart monogram.

Overlap letters and omit centers for a punk effect.

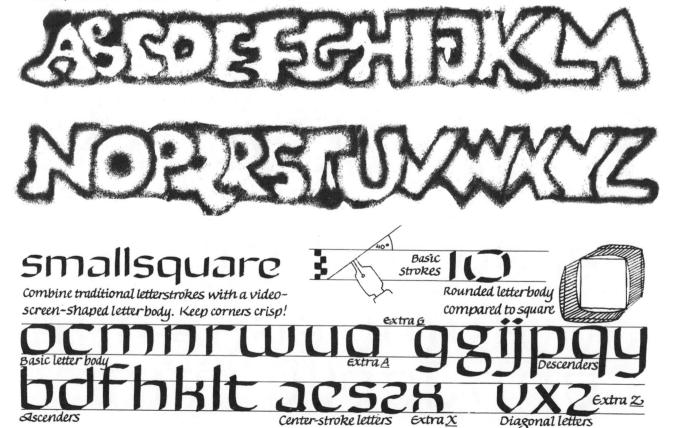

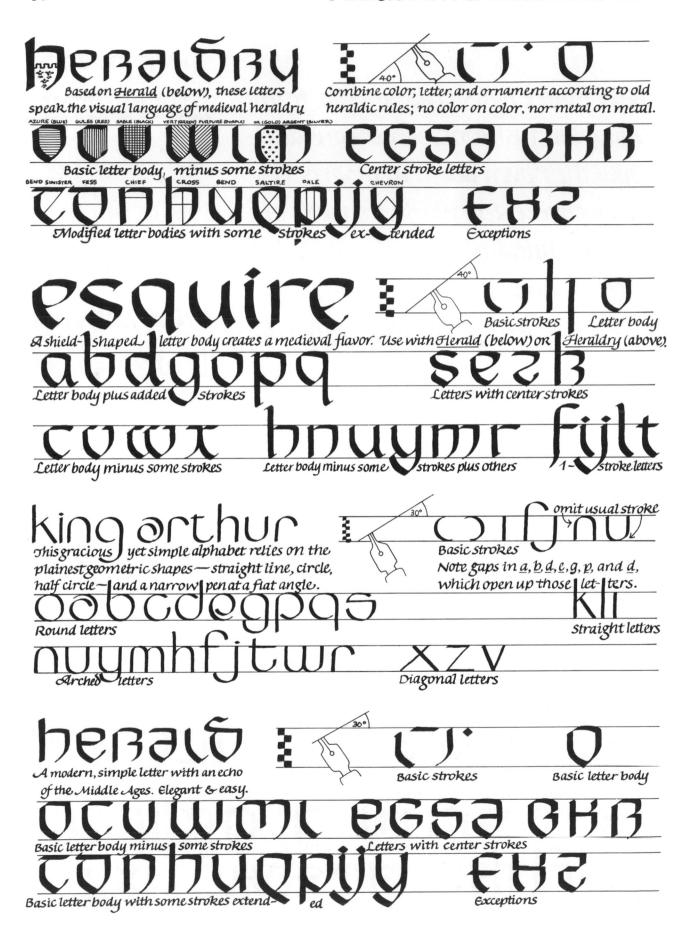

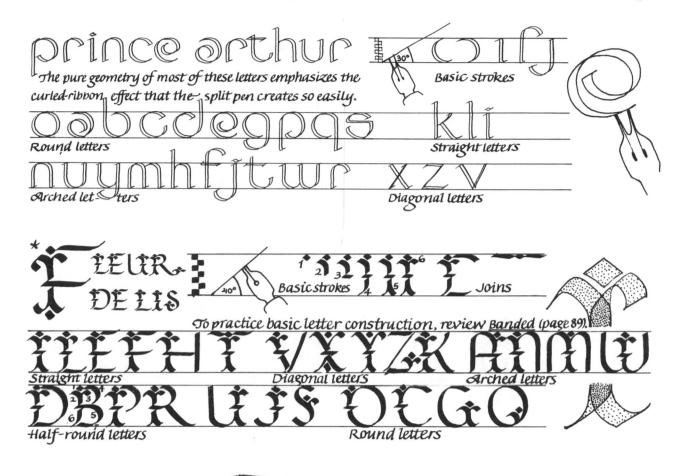

marks not only the birthday of Ann Radcliffe (July 9) whose 'Gothic' novels focused 19-century England's fantasy on their medieval ruling class, but also Bastille Day (July 14), when the French did away with theirs. Bogus, now defunct, or meticulously correct, a coat of arms can enhance your calligraphy.

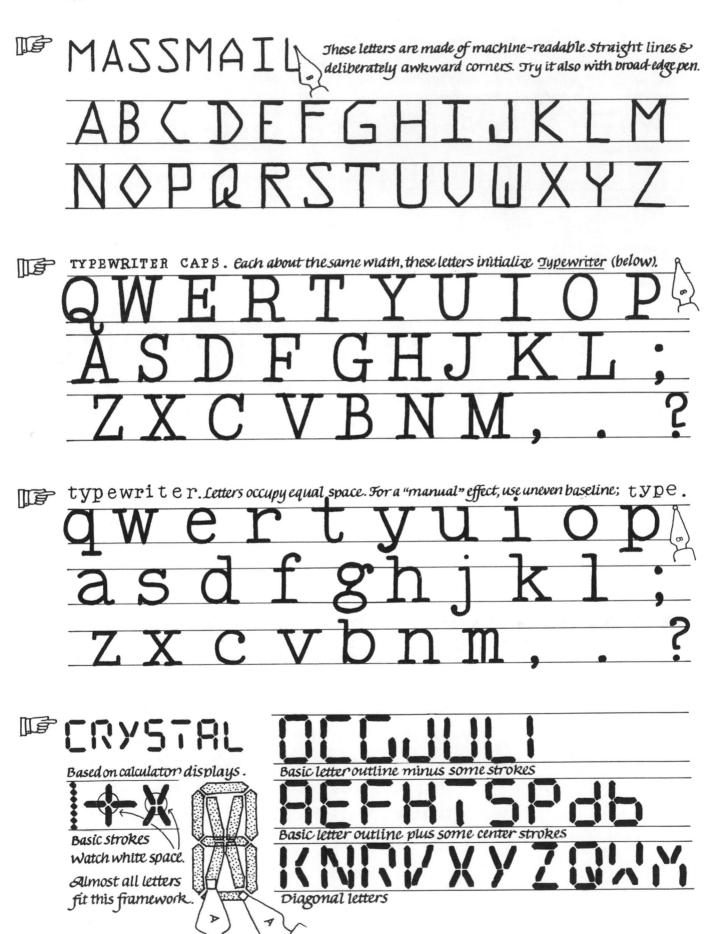

his week, use calligraphy pens to recapitulate a century of high technology—from hunt&peck to high-speed ink jet. You'll find many uses for these familiar let ters and for the new calligraphic techniques they teach you.

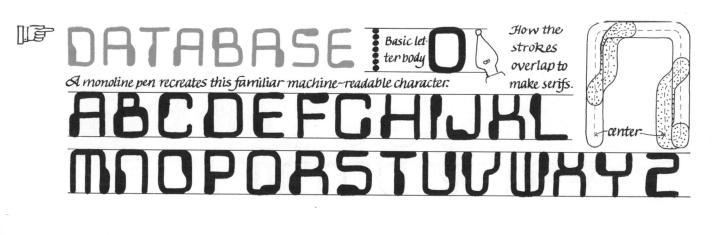

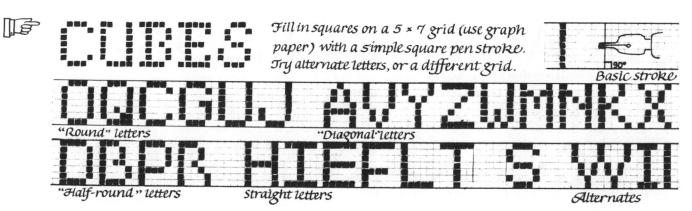

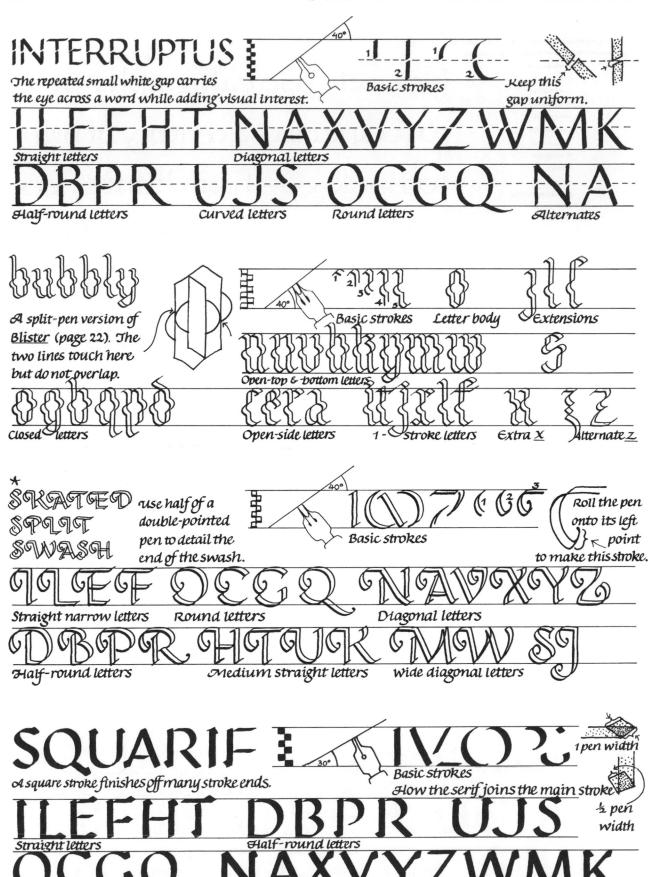

Diagonal letters

Round letters

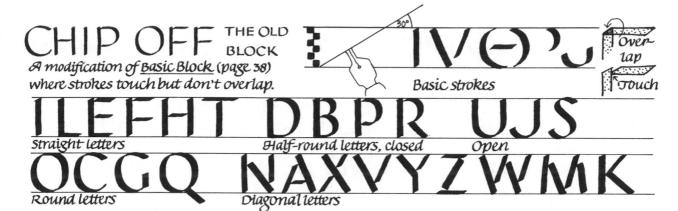

In the United States, more babies are born on Tuesday than on any other day of the week. Celebrate the arrival of a Tuesday's child (or almost any other except perhaps a Wednesday's!) with a handlettered copy of the traditional poem. Personalize it with the baby's date of birth, name, height, weight, and a sketch, photograph, or handprint.

MONDAY'S CHILD IS FAIR OF FACE

Trusday's child is full of grace

WEDNESDAY'S CHILD IS WEAL WITH WOE
Thursday's child has far to go
Friday's child is loving and giving
Saturday's child works hard for a living

But the child that is born on the Sabbath Day is bonny and blithe and good and gay.

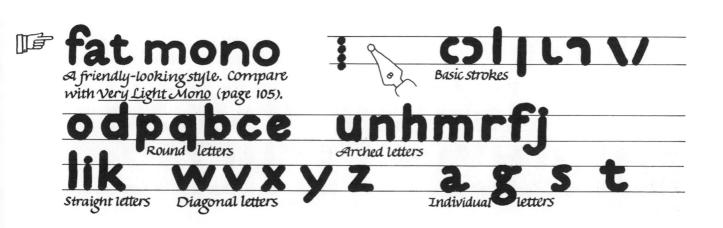

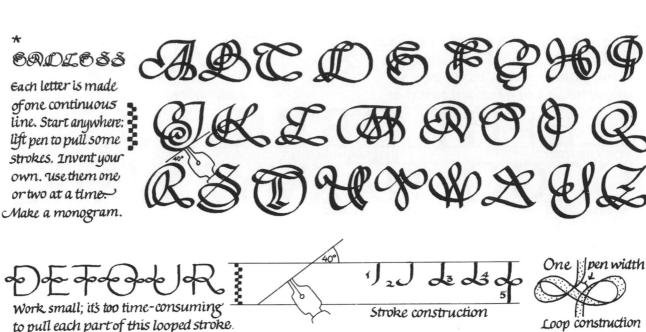

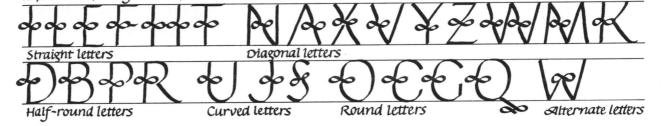

ROTTOE CAPS

Don't crowd these capitals when you use them with Ronde small letters (page 51) and don't use them to write in OLL CAPITOLS!

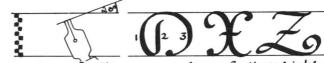

No basic strokes or family groups are shown for these highly individualistic letters. Copy carefully; emphasize similarities.

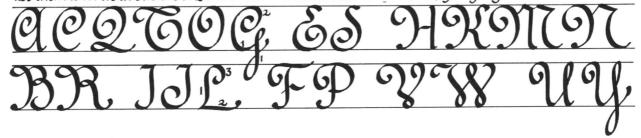

HIGHLAND

An extra-tall version of the ever-adaptible <u>Neuland</u> (page 105). Keep its corners heavily overlapped and pen angles crisply accurate. Simple.

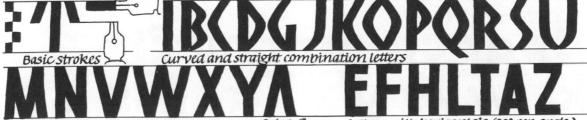

Diagonal letters

extra &

Letters with horizontals (90° pen angle)

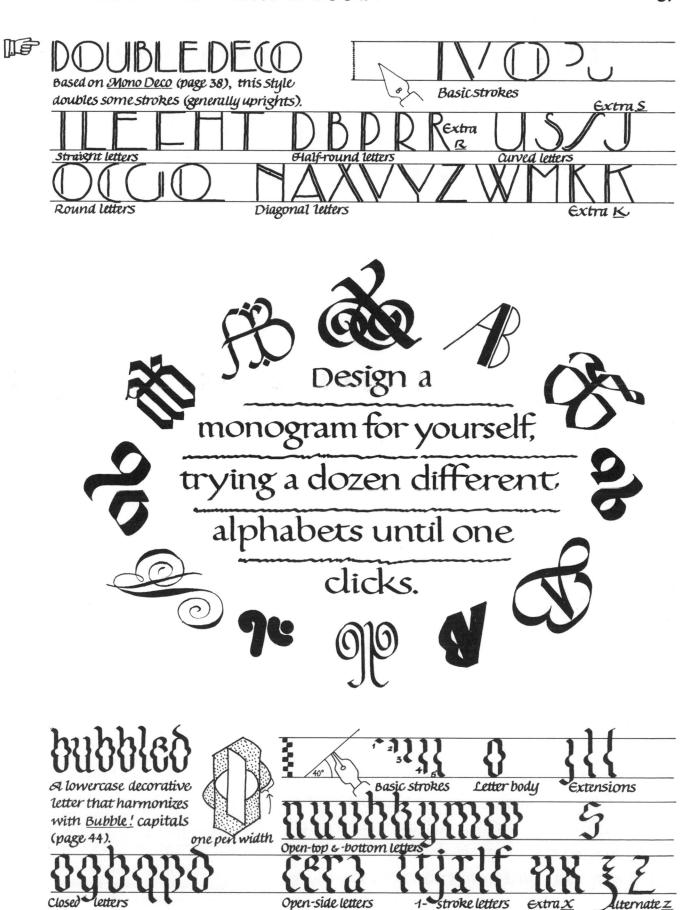

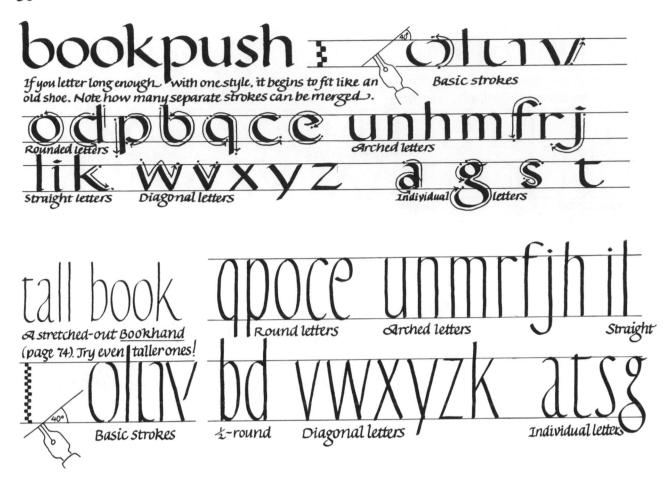

Non-calligraphers always wonder how we make the lines all come out the same length ('flush left and right'). One easy way is to letter each line first on a piece of scratch paper, measure the gap at the end, divide by the number of wordspaces, augment each wordspace by that amount, and then reletter. Next try pencilling-in the words, eyeballing the spacing and correcting it in the final inking-in. As you progess, you'll be able to 'justify' by winging it, instinctively stretching or squeezing, or hyphenating as you go along. It's akin to approaching a staircase so that you put your foot upon the first step without falling or to making your money last from one payday to the next.

WORDSPACING

justification is no problem if

Divide this gap.

justification is no problem if

... into four parts ...

justification is no problem if

... and distribute them evenly.

justification is no problem if

LETTERSPACING

justification is no problem if you manipulate letterspacing when wordspacing won't suffice.

Gaps in second line are too large.

justification is no problem if you manipulate letterspacing when wordspacing won't suffice.

Spread letterspacing slightly to reduce wordspacing.

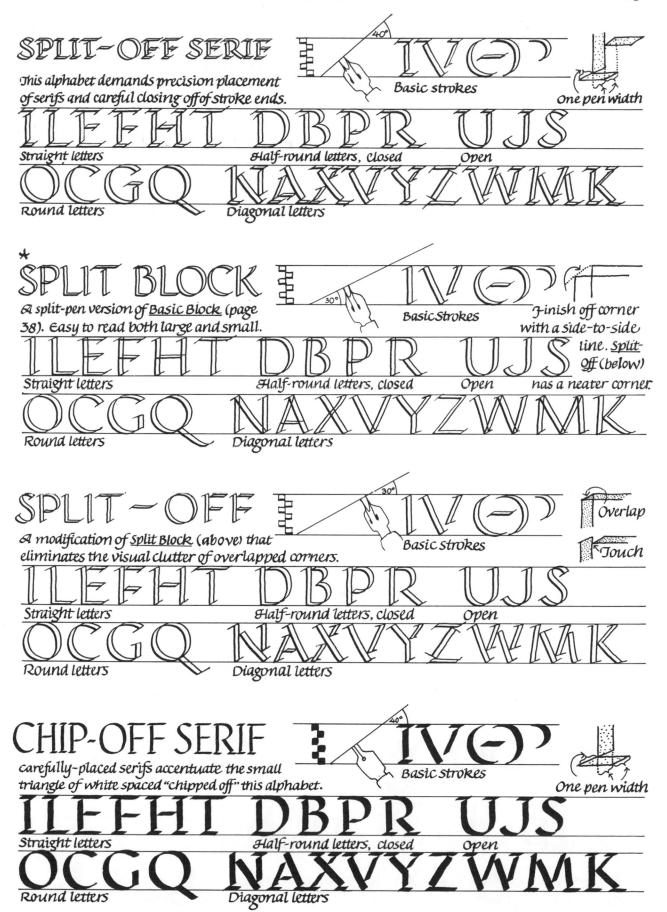

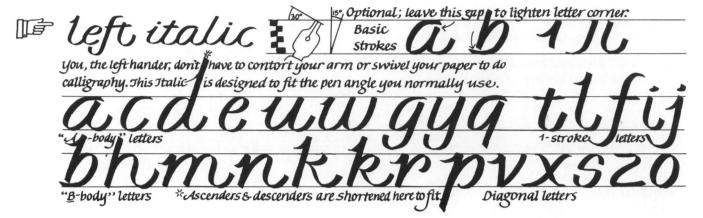

If you're one of the 15% of humanity that writes from the left, celebrate it with these special-for lefties alphabets. Then review this list of other styles. (Eat your hearts out, righthanders!)

12 Stringy 58 Leftbook Lower Kingdom 16 Palmer 70 Square Point Robot Alchemy Weirdness 92 Old West Copper Brush 12 coiltic 17 Monoline Book 38 united States short Cuts 58 12 Wild West 20 Monodeco Lettersweater Sprung cut Waitu zap! 62 Solid 3-D endüre Very Light Mono Heavy Copper 21 Monoblock 14 Heavy Caps пуреwriter Caps 62. Splats Shalom 71 Flat Block 84 Raised Roman 97 Heavy Mono 24 Sabra 62 Alias 1 Copperplate Neuland Hatching 14 Fat Shadow Typewriter 72 86 3-D 97 Lightland 62 Alias 2 Copper Caps 86 Liquid Crystal Sunburst 105 15 Fattest Mono 24 OpenWest crystal 72 98 Shade Database 63 First Impressions 72 copperwire Super Stencil Flat Light Heavyland 25 Backslant Alphabet Nouveau Ground Shadow cubes 63 Lit-up Copperstraight uplight 15 Fat Caps 25 Bricks 65 Вапсо Flat Gothic 8 Weathered 15 Runes 26 Masquerades Fat Mond Copper Loops Marque Sidelight Namor 10 Monoitalic 16 LightsOut вiighland 66 Squarecut 78 Sidelined 89 2½-D 99 Downlight Parasol 11 Lightweight Mono 16 Uplight 3/4 Left 33 Double Helix Doubledeco 67 Square Edge 78 Greek 90 Spray 99 Downlight & Right 16 ExtraLight 70 wide Land 18 Upper Kingdom 91 Minimalist Dryland Left Italic 33 Diamond Jim

This symbol indicates an alphabet style suitable for lefthanders.

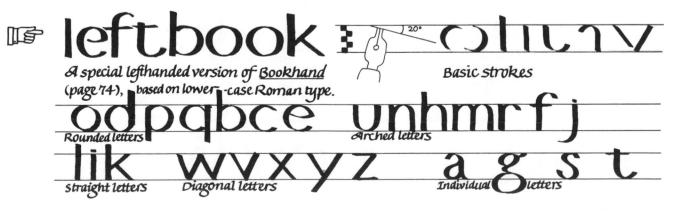

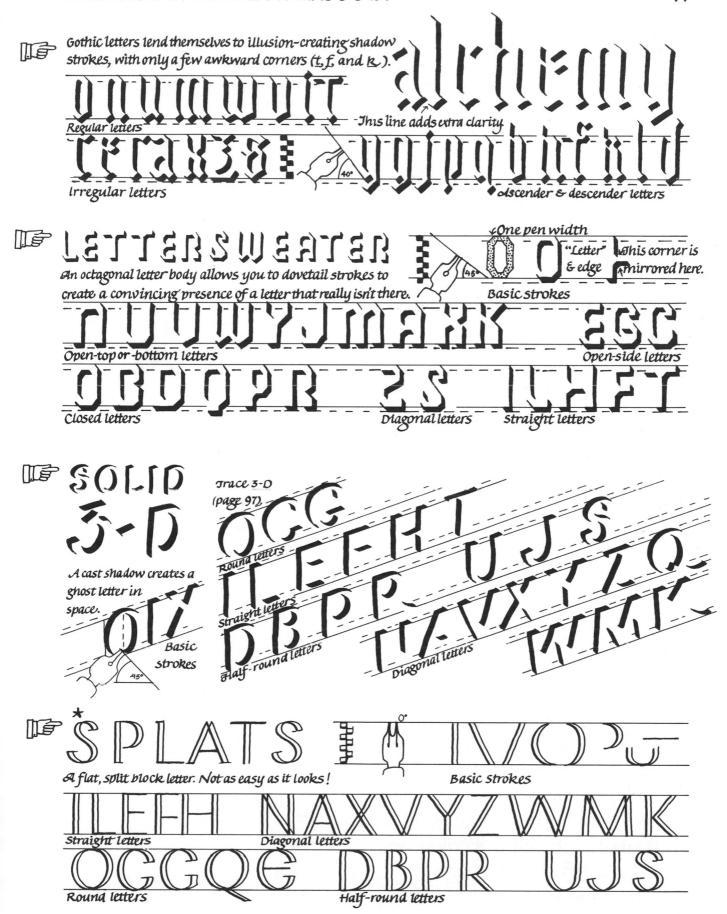

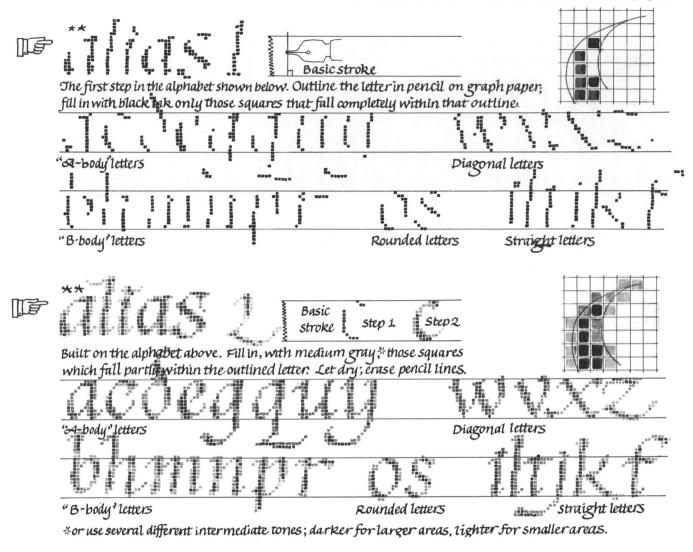

ugust 22 marks the birthday, in 1862, of Claude Debussy, composer of impressionistic music. Introduce soft contours of pointillism into your calligraphy, using letters built up of soft dabs of color, or pages built up of soft-edged, soft-hued letters.

ow and then, shed by a blossoming tree,

a petal would come down, down, down, and with the odd feeling of seeing something neither worshipper nor casual spectator ought to see, one would manage to glimpse its reflection which swiftly — more swiftly than the petal fell—rose to meet it; and for a fraction of a second, one feared that the trick would not work, that the blessed oil would not catch fire, that the reflection might miss and the petal float away alone, but every time the delicate union did take place, with the magic precision of a poet's word meeting halfway his, or

a reader's, recollections.

SPEAK, MEMORY Vladimir Nabokov

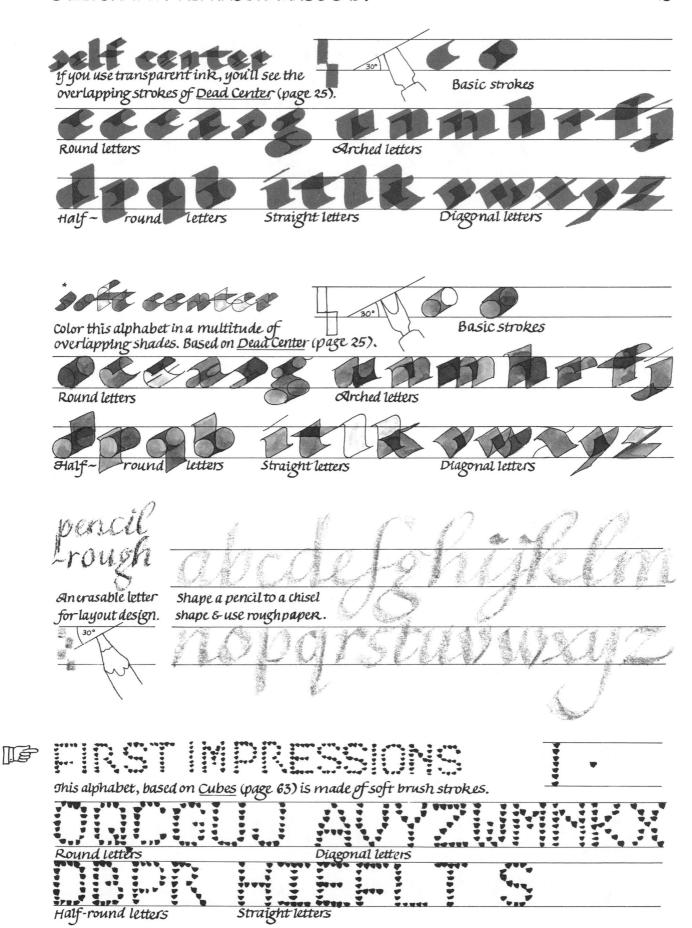

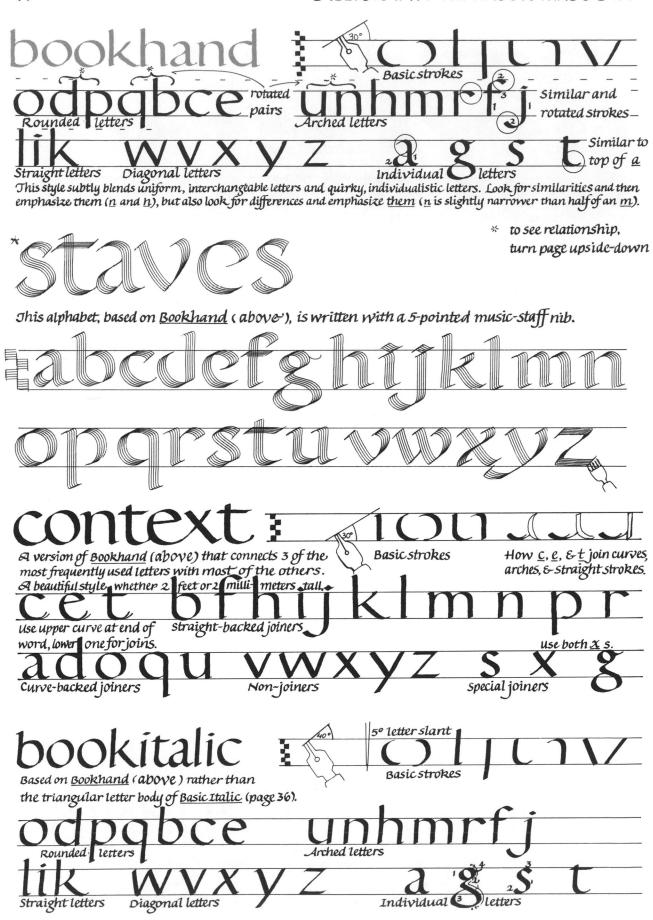

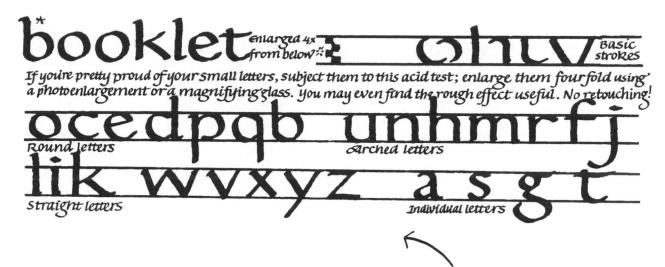

If I had to choose just one alphabet style to letter for the rest of my life, this would be it: the simplest Bookhand, medium weight, with hairline serifs, short descenders, and generous word- & linespacing

booklet 3 chw ocedpqb unhmrfj lik wyxyz asgt

*Original size of alphabet enlarged four times above .

Final size of letters reduced 4 from alphabet below.

bookscroll to the print of the

booksci		M ()	111	
split strokes must join each or or be closed carefully at ends		Basic strok		nd these strokes take neat joins
	~ ~ ~ ~ ~ ~ ~ ~ ~ ~ ~ ~ ~ ~ ~ ~ ~ ~ ~	1110 10 100	5 15 P 3	
Rounded letters	CE !	Arched letters		
Straight letters Diagonal	letters X Y	Z al	al S letters	t

Alternate

Half-round letters

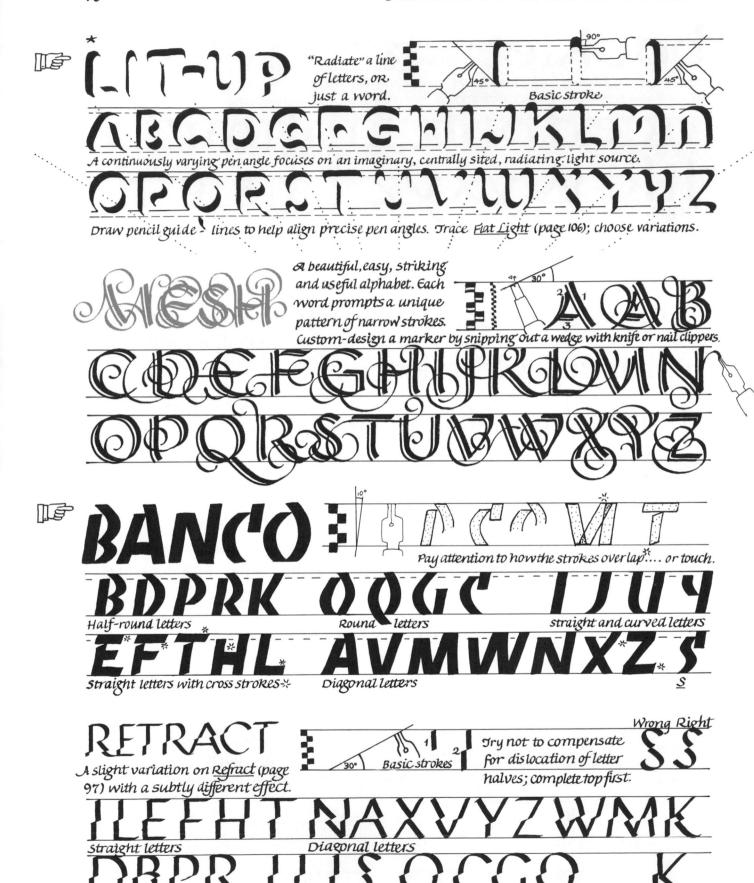

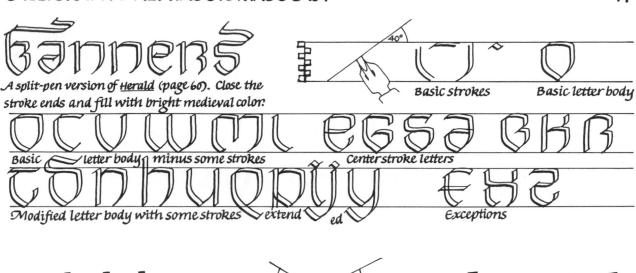

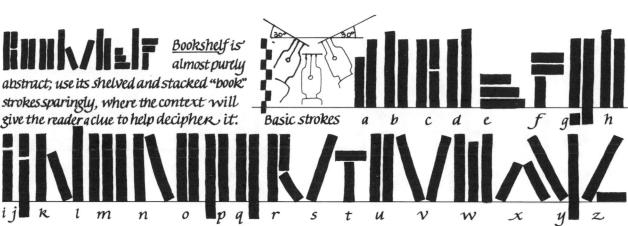

Contemporary Italian Lighting' Newbury Street and the Chestrut Hill Mall Boston, Massachusetts 617 - 411 - 0121

Labor Day starts the work year for many businesses. If you are self-employed, use this lull to letter yourself a business card, or bring your old one up to date with a rendering that reflects your level of calligraphic expertise. Don't put in too much information or too many different visual messages.

Median Mail, Vanderbilt Heights, California ~ 92044

A square nib makes these segments.

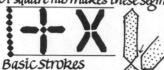

Diagonal & straight stroke ends have to line up precisely.

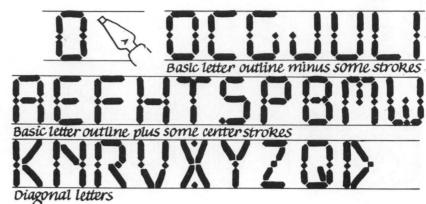

a near~ monoline

alphabet. Compare

this with

Square Point (below).

Basic strokes

Note how curves thin out here.

Straight letlers

Diagonal letters

A stretched <u>Neuland</u> (page 105).

Letters with horizontals (90° pen angle)

Alternate Z Extra <u>A</u> Diagonal letters

Curved and straight combination letters

Alternate S

SQUARE

45° pen angle makes strokes' ends pointed, corners angled.

Basic strokes

Note how curves thin out here.

Straight letters

Diagonal letters

The first Friday the 13th of every year is Blame Someone Else Day; the rest of the year your calligraphic flubs are your own fault. Since September is Be Kind to Editors and Writers Month, learning to critique and proofread your own work will help make everybody's job easier. First, judge your work graphic-cally; turn it upside down, step back, and squint at it; are the horizontals horizontal and the verticals vertical? Is the text of an even texture? Do the right things engage the eye? Next, go back to the original that you worked from and read it aloud to an assistant who checks the copy that you lettered. Be sure you read everything; say 'capital b,' 'semicolon,' 'period,' & spell out any potential problem words. With patience & luck you'll catch most of the omissions, repetitions, & typos, but don't stop yet. Have a third person check off, one by one, the corrections you did so no new errors creep in there! Even then one may still slip by...

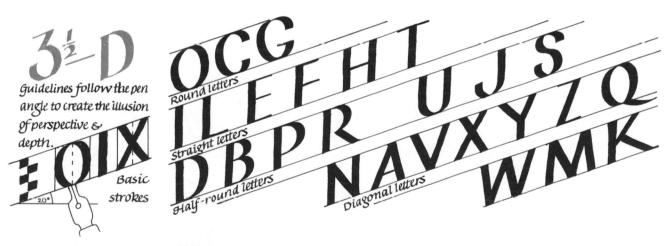

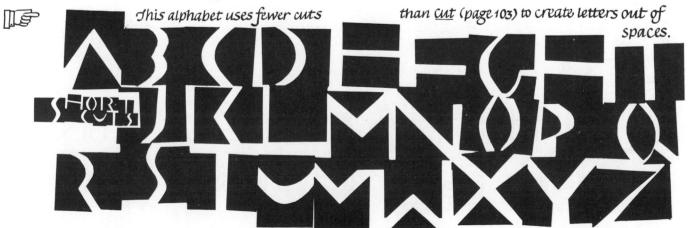

Sometimes less work has more results. Concentrate your effort & time on the most important two or three words in any poster; emphasize them; then employ your easiest, simplest lettering style for the details.

GALA GOLDEN ANNIVERSARY CELLBRATION AND BALL-MAY 21, SIX O'CLOCK OPERA HOUSE

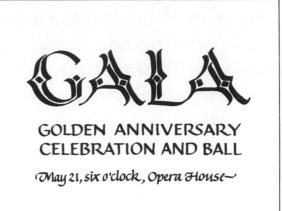

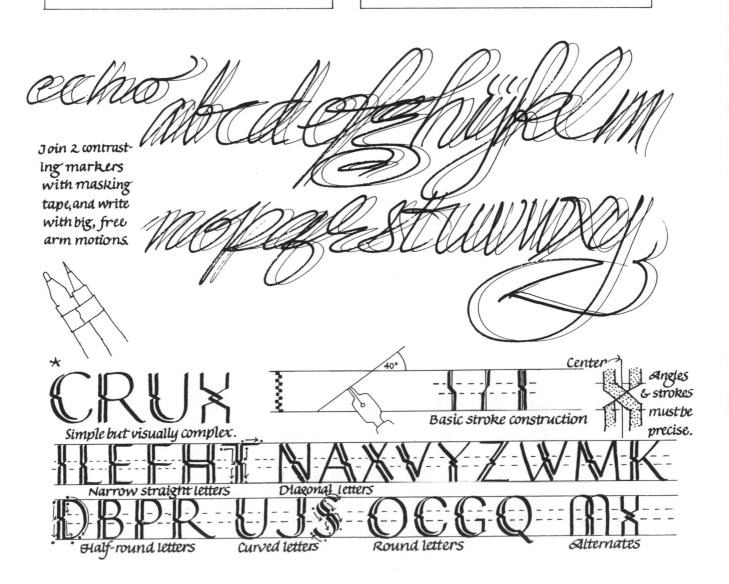

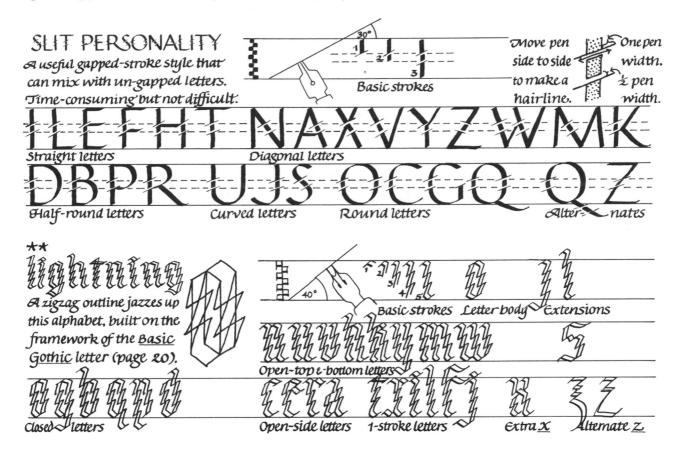

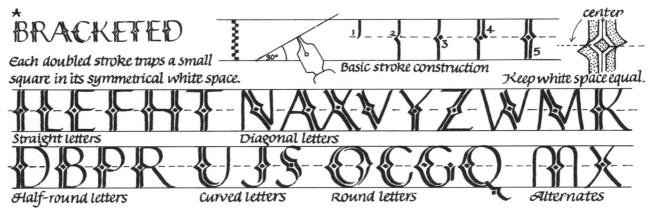

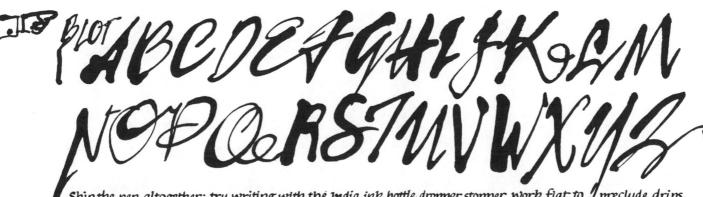

Skip the pen altogether; try writing with the India ink bottle dropper stopper. Work flat to preclude drips.

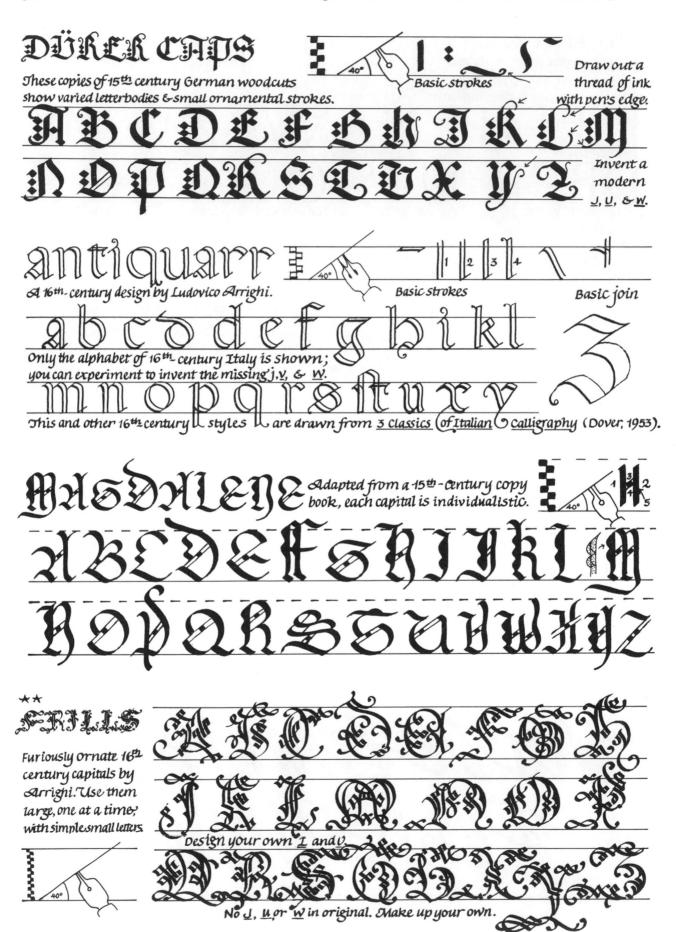

This week includes Ancestor Appreciation Day. In memory, copy these historical alphabets using your eye, not your brain; copy what is actually there, not what you think you know is there; resist making all those minor visual adjustments that dilute an alphabet's flavor. To check this tendency, turn your paper &

your original upside-down; this keeps your brain from interfering with your eye.

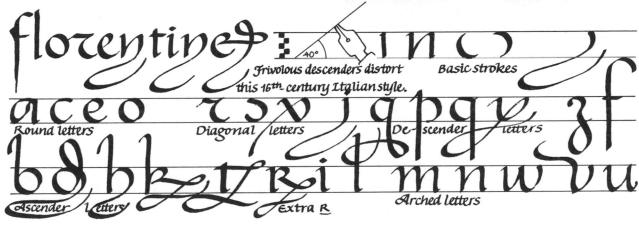

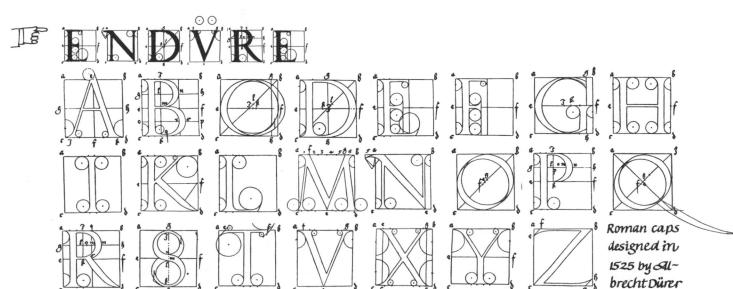

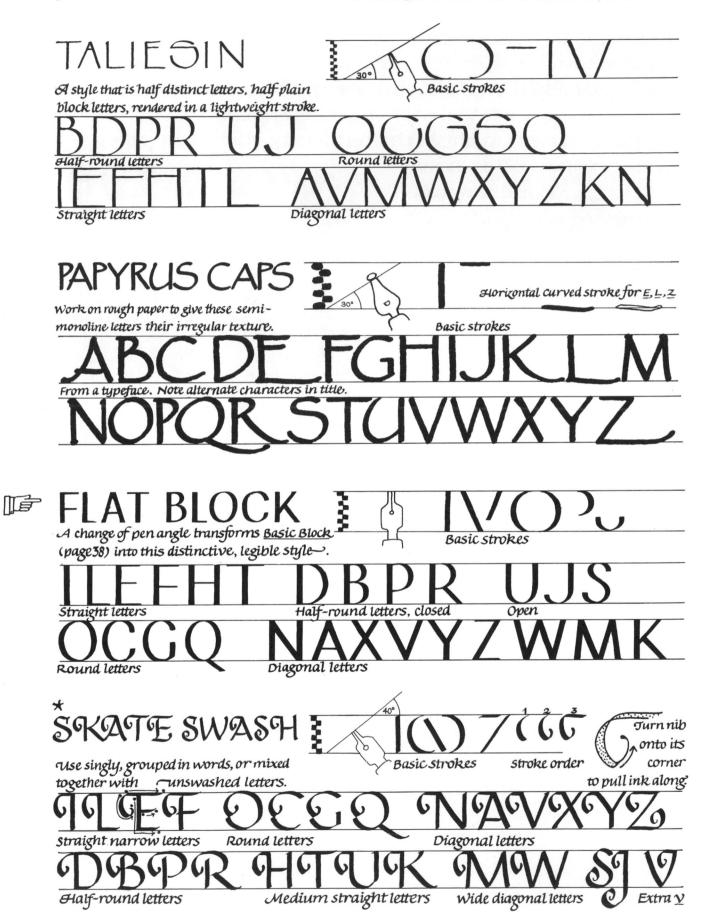

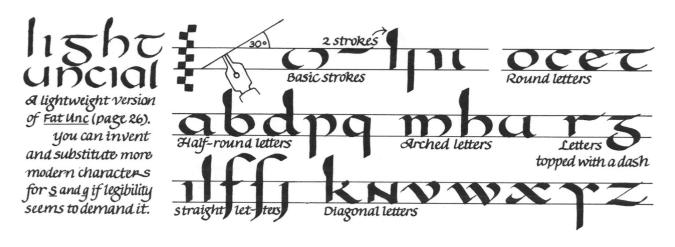

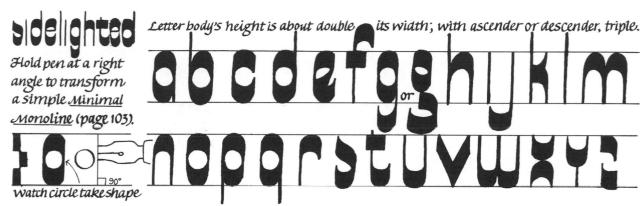

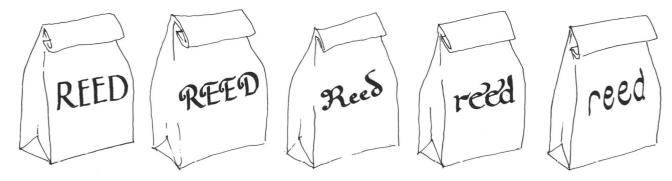

Make somebody's day when you make somebody's lunch." Add a handlettered note or a new style of name every day.

*Be ready for universal Children's Day, the first Monday in October; practice up for School Lunch Week, which follows the second sunday in October.

	nge pressure fabruptly
copperplate 1007	Stroke is straight most of its
Based on 18th & 19th century handwriting: Exaggerate its slant	length and then curves in
and the ascender height and the difference between thick and thin strokes.	a semicircle.
oace rsx 3/9	UQDI
Round let-ters Individual letters Descenders:	. round and straight
olnk tal mnuvi	U PS
Ascenders: roundand straight	Alternates

Victorian handwriting that we call 'Copperplate' was the accepted form for social and business correspondance, and for commercial transactions.

Try several variations during Bookkeepers & Let

Position of the Hand in Flourishing.

In executing broad sweeps with the pen, and assuming a position that will give greatest command of the hand in flourishing, the position of the pen in the hand should be reversed; the end of the penholder pointing from the left shoulder, the pen pointing towards the body, the holder being held between the thumb and two first fingers, as shown above.

during Bookkeepers & Letterwriting Weeks, the second week in October.

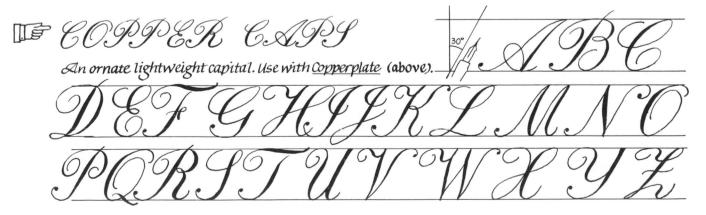

COMPONUTE Symmetry Letter construction features small and large corner curves with a minimum of overlapped lines. Symmetry Letter construction features small and large corner curves Symmetry Letter construction features small and large corner curves Symmetry Letter construction features small and large corner curves Sold of the straight Strai
COppers trought An upright version of copper plate (page 86) that is easier for a right—hander. O C C J J J J J J J J J J J J J J J J J
od version of Copperplate (page 86) that reverses the letter angle and shifts the stroke weight downward to fit the right-handed calligrapher's pen. Round latters Individual letters Descenders round straight & curled Ascenders: round and straight Arched letters Alternates
Basic strokes These letters nave lots of decorative Swashes. There are very few thick strokes, and what few there are arent very thick.

Bury the hatchet but mark the spot.

Columbus Day celebrates the discovery of the Americas, North & South. Pre-Columbian American Indians, while they did not practice alphabetic writing as we know it, had highly-developed traditions of graphic forms to supplement their oral culture and decorative arts that can lend a strong flavor to the alphabets of today. Use them to create an atmosphere.

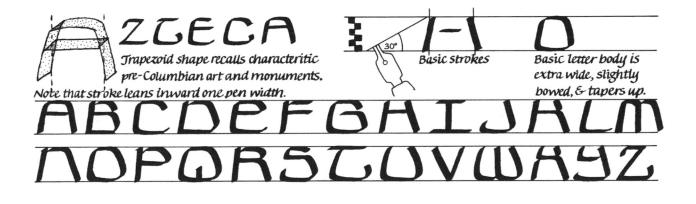

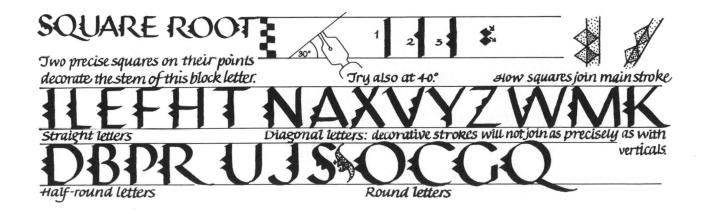

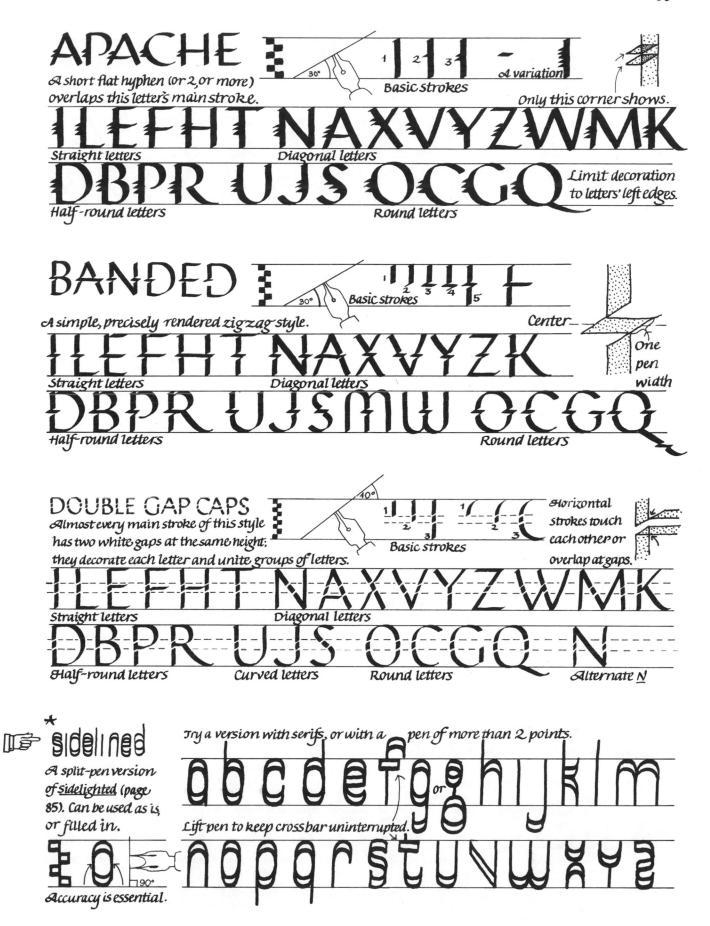

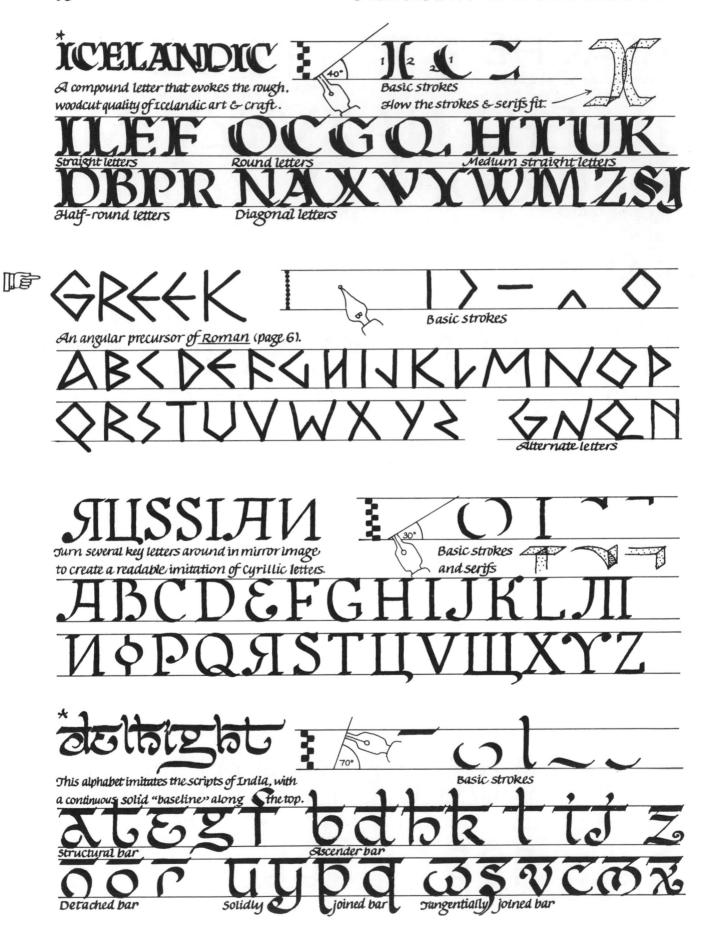

PEACE
PEACE

united Nations Day falls on October 24, the anniversary of its founding in 1946. Commemorate this with 'Peace' written in half a dozen languages, or use Westernized versions of non-Western scripts to lend international flavor to menues, announcements, logos, and headlines.

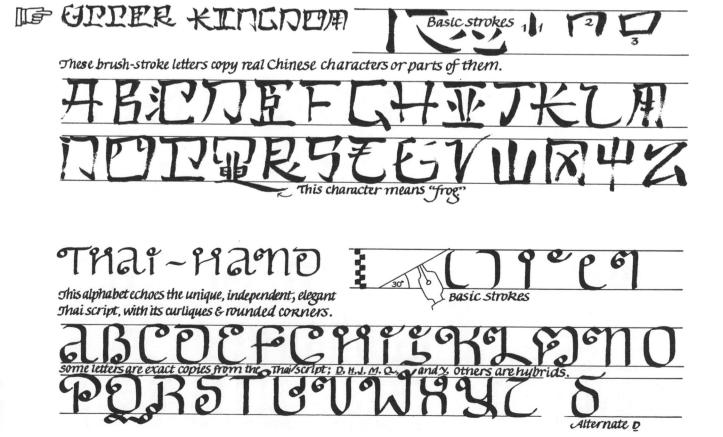

	Based on a contemporary Italian logotype, this alphabet Overlap Jouch Jouch
	boxed letters Sarched letters
	ABEFGHHPR J Letters with norizonal center strokes
	Useful for its jarring impact & contrast with softer styles, not for prettiness or legibility.
	"A-body" letters This style is based on a sharp triangular letter body (in fact, you can round it; but slightly). Straight letters
	"B-body" letters Diagonal letters
F V	erratic line width, letter shape, joins, letter size, letter angle, and spacing characterize these creepy letters made with an ink dropper
	ABRIDEF 6 HIJKLMO
	OPORSTUVWXY2
	* Clift pen after first half- stroke and reposition it further up, overlapping * Oll FU * Dasic strokes Letter body * Extensions * Extensions * Dasic strokes Letter body * Extensions
	for second half-stroke. Overlap Open-top and-bottom letters Closed letters Open-side letters 1-stroke letters Extra x Alternate Z

SPRUNG

Experiment with other forms for <u>G,K,Q</u>, &<u>X</u>.

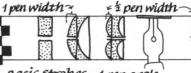

Basic strokes 1 pen angle

No diagonals

ABCDEFCHIJKLINN

None of the broadstrokes overlap. Compare to <u>Meuland</u> (page 105) for many subtle differences

OPORSTUUW8YZ

Be careful to maintain contrast here.

Sometimes you are asked to do ugly calligraphy (or 'malligraphy') to convey specific & startling visual

effects. Work in an uncomfortable chair, with inappropriate, malfunctioning tools, preferably when you are in a bad mood. Do a second and third draft and choose all the worst letters for your final design.

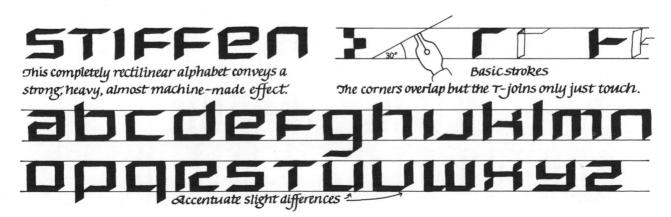

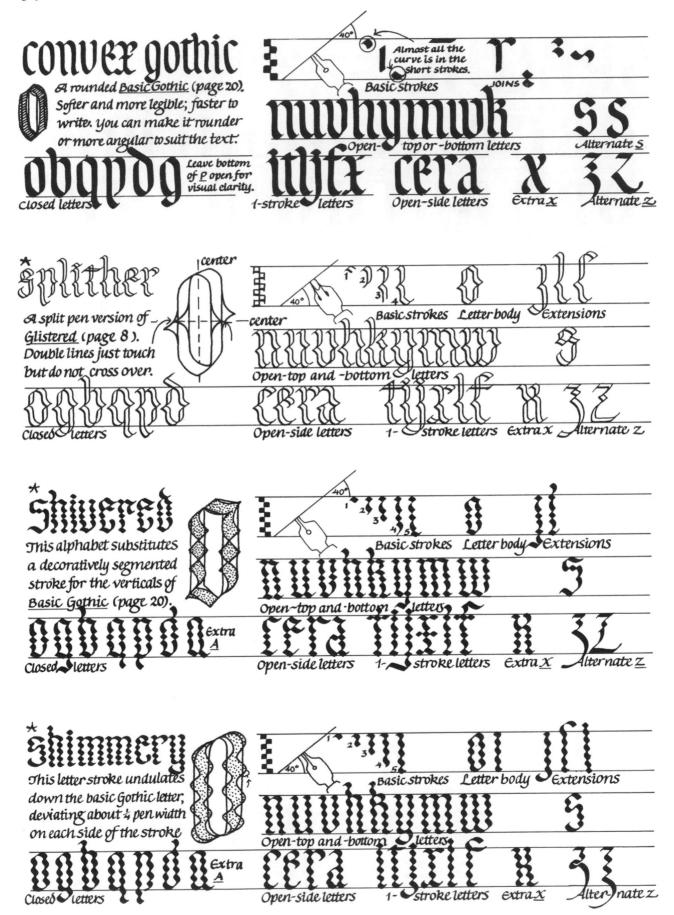

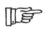

TRUNCATE OCOS Based on a typeface named threshold, this alphabet fools Basic strokes

the eye into thinking that the top & bottom are hiding some of these phantoms are shown shaded in here.

Straight letters Straight letters Arched letters Arched letters EFFACE extra e G G Shalf-round letters Center-stroke letters

The world of optical illusions is at the tip of your calligraphy pen. You can enchant the viewer's eye, charm it into seeing not two dimensions but three, precious metals instead of paper, complete letters where only a swash and an empty space exist.

See Gothic Sofilight (page 30) for details of this shading technique.

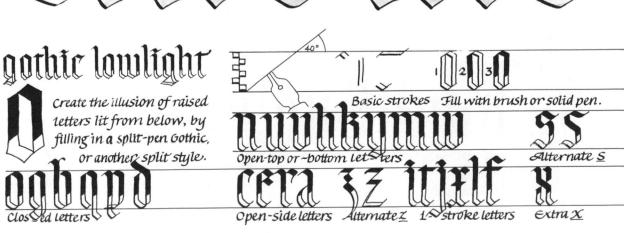

In the hands of a skilled calligrapher, the simplest poster can call up images of other kinds of signs in the urban landscape. The right alphabet style & letter arrangement create the movie marquee, lit-up neon, a stencilled warning:

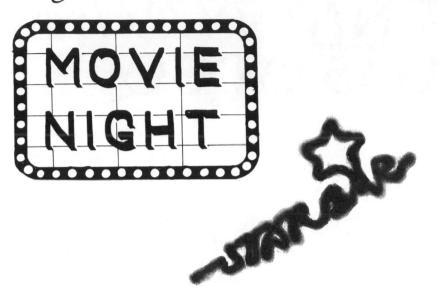

POST NO BILLS

LIQUID CRYSTAL

A narrower, slanted, modified version of Crystal (page 62).

Basicstrokes / Letter body

Notice that many diagonal letters do not quite conform to basic grid shown above.

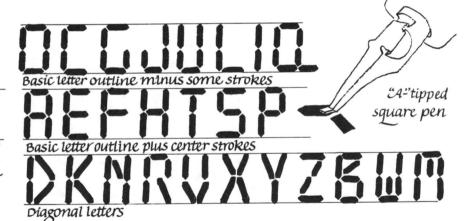

SUPER STENCI

Break these letters at both mid-stroke &

corner joins.

Basic strokes

Note how strokes line up here

Compare to Square Sten-

Straight letters

Half-round letters

Daying latters

Diagonal letters

MODEON
This alphabet, degived from a typeface, links

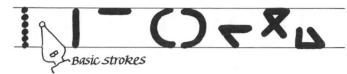

ABCDEFGHIKLMUO PORSTUVWXYZ D(SE

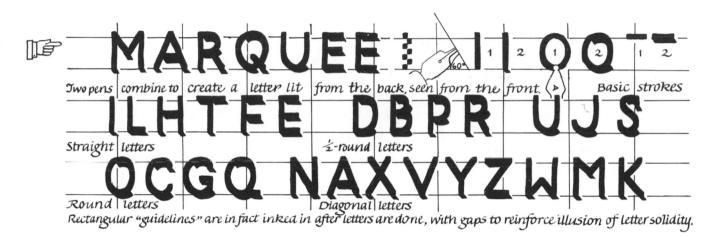

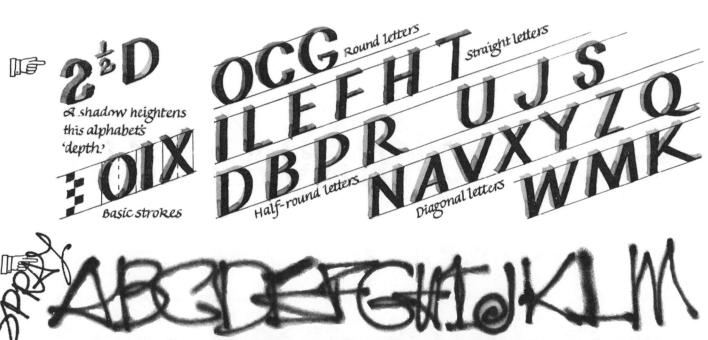

The airbrush for small size, or aerosol paint can for wall size, letters. Move smoothly & quickly; experiment.

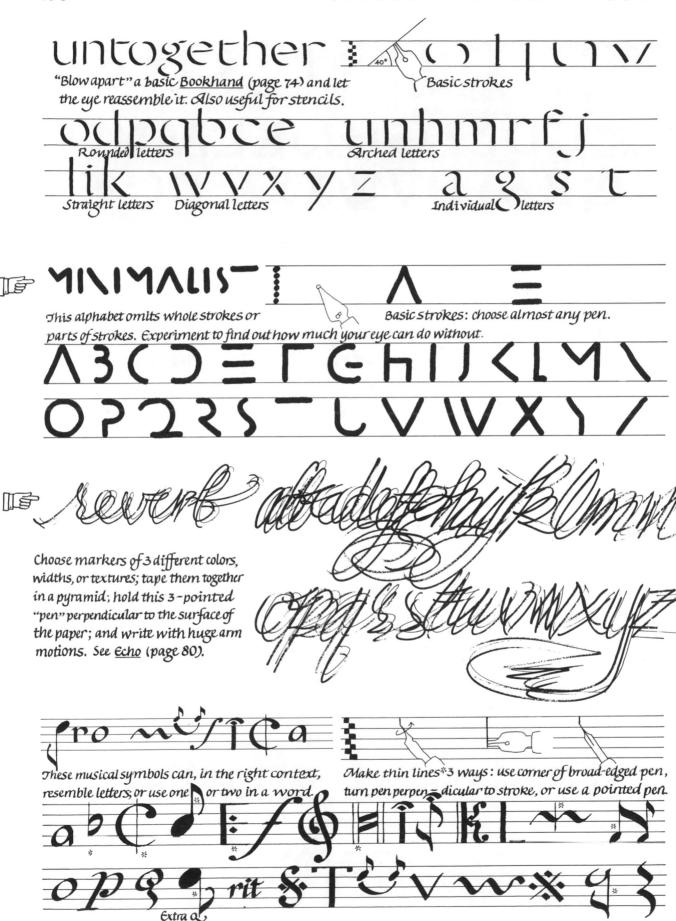

derherd.

The most wonderful thing about the eye is its quest for meaning: It seeks letters, craves reading squeezes information out of marks. A few letters read the same upside-down or mirrored (H,O,X,A); others

(wow!) reveal secret messages.

Read Inversions by Scott Kim. McGraw-Hill, 1981.

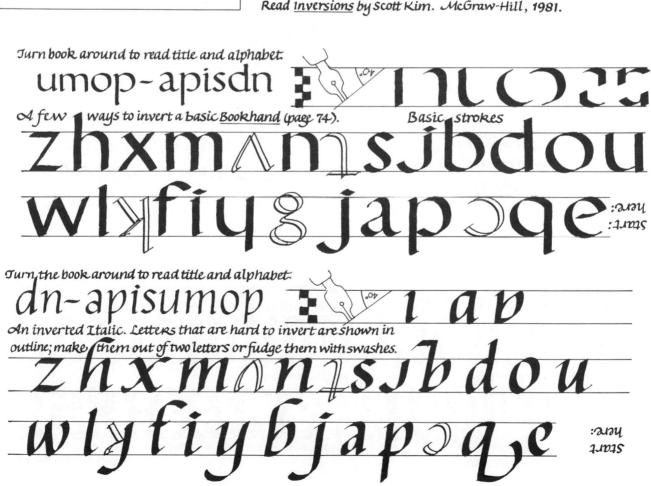

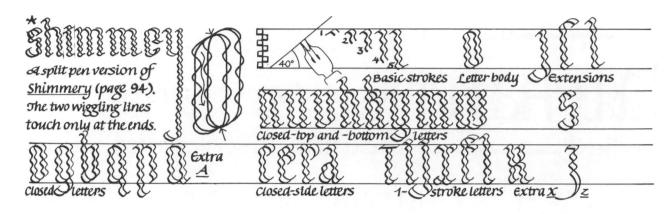

A good conscience is a continual christmas

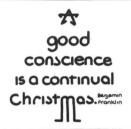

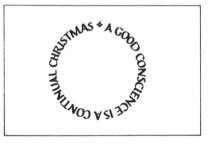

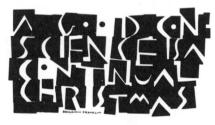

A good conscience A lisa continual Christmas. Benjomin Frankin

A good conscience is a continual Christmas

Write your favorite quotation 6 different ways with 6 different letter styles, to jolt' yourself out of your accustomed design habits. Each new look implies a different speaker, audience, volume, & tone of voice. Start designing anew each day; compare all 6 versions at week's end.

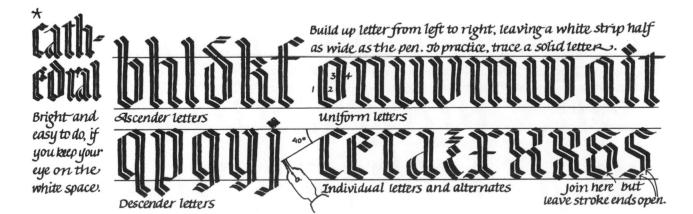

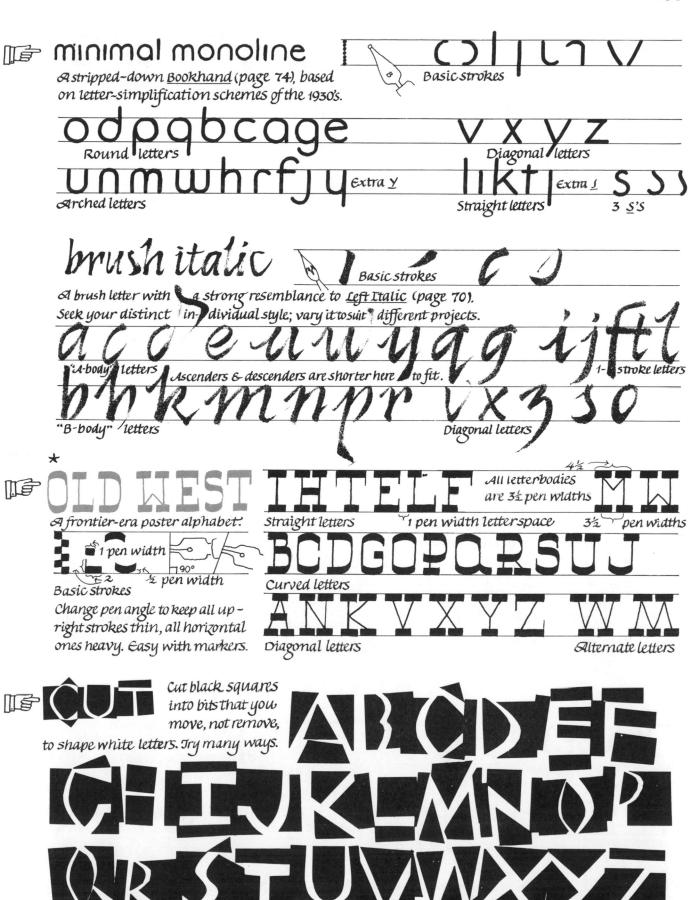

Now that you know nearly 300 alphabets, expand your repertoire by at least an order of magnitude; review the relativity of a letter's weight. The size of the pen that you have or the letter that you want are not individually crucial; it is their ratio which matters when you letter a style. The width of the pen determines the height of the letter. Each style in this book has a recommend ratio; use it to begin with, modifying it later if you prefer. But always, if you change letter height, change pen width.

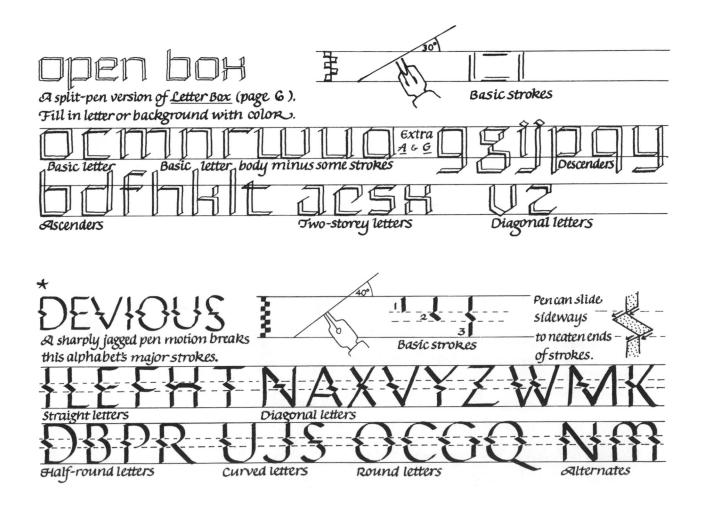

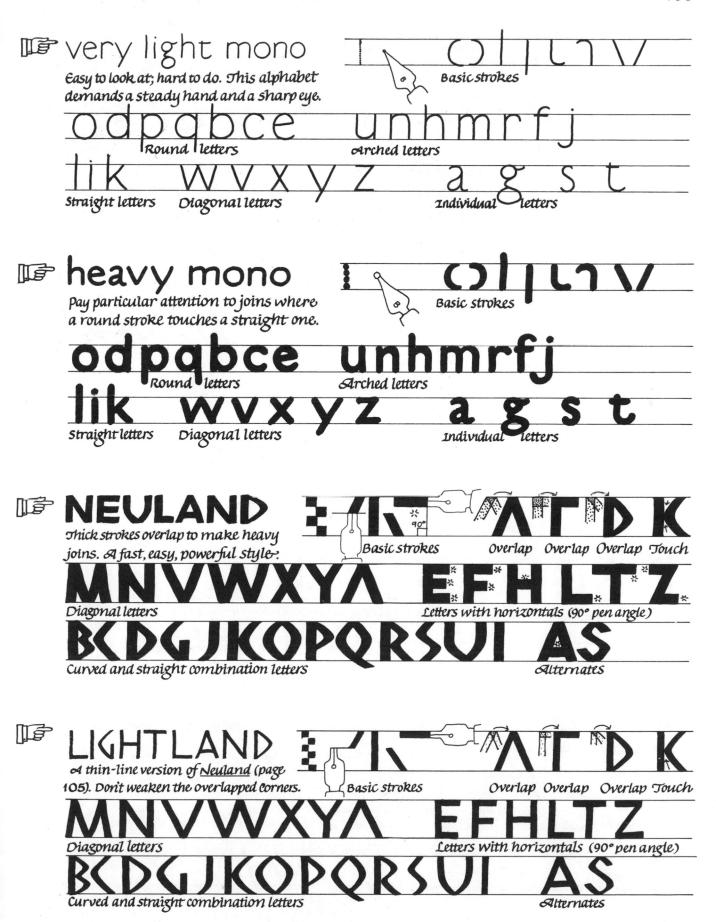

use this basic alphabet when you write the shadow alphabets here and on pages 33, 14, and 107.

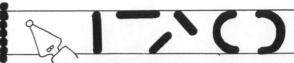

Basic stroke

Shadows create the illusion of a low light source.

Basic strokes

Modify letter contour or stroke angle slightly to compensate for possible ambiguity of ${ t I}$, ${ t P}$, ${ t I}$, and ${ t Y}$.

Extra Y

I SIDELJG!

Basic strokes

Compare with uplight (above). Downlight (below), and other shadow alphabets for solutions to ambiguous letters.

A 90° pen angle creates shadows cast from above.

Basic strokes

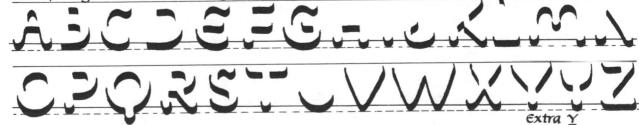

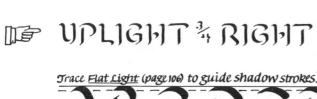

December 21st marks the winter solstice, when the day is shortest Ethenight longest in the Northern hemisphere.

Practice vertical lettering: flush left and right, and centered, with a variety of styles, making tiny spacing adjustments

DOMU TIEHL 🕉 KIEHL

Light appears to come from the left and above, the usual source for righthanded writers

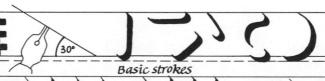

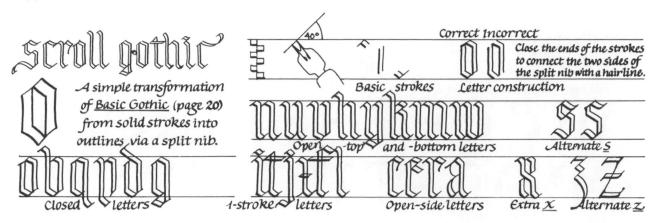

Because the custom of sending out cards at Christmastime was popularized by the-Victorians, it has come to be linked to the Gothic Revival style that was all the rage at the time-You can combine "Christmas letters" and "Voice of God capitals" with medieval borders to infuse your handlettered greetings with the peculian flavor of both the 19th and the 14th centuries. Fill the capital strokes and interior, lettery spaces with texture, colongold, decorations or seasonal ornaments. Or create a 20th century design by treating Gothic letters as abstractions.

Make these hexagonal kaleidoscopic letter multiples on a grid to guide placement. No two are alike!

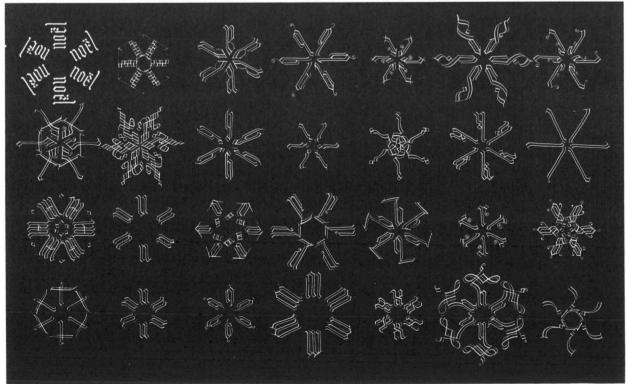

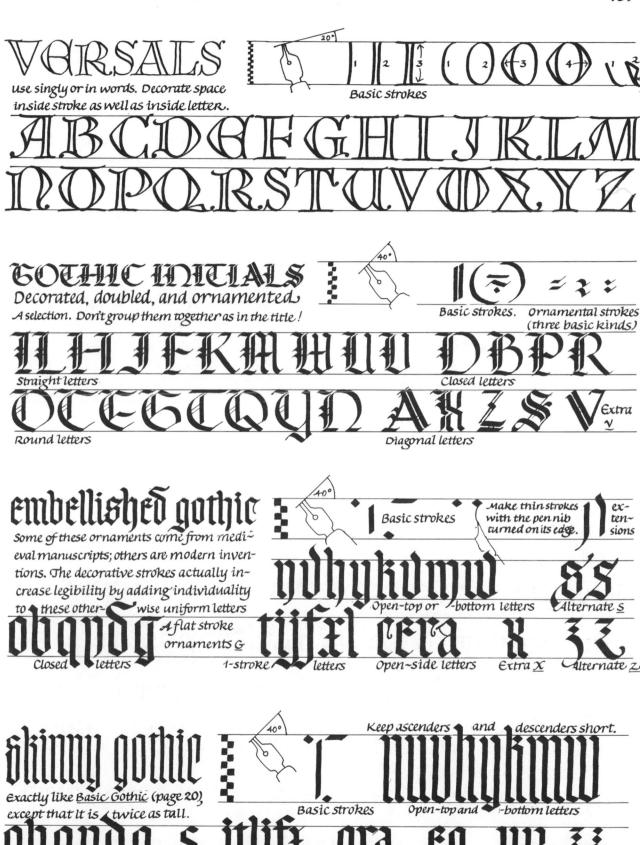

Open-side letters

Letters can be built up of almost anything; even themselves. Try grids of varying fineness or coarseness, depending on the letter and the viewing distance. Compare First Impressions (page 73), Cubes (page 63), and Alias 1 & 2 (page 72).

Though the year of alphabets is complete, your acquaintance with calligraphy has just begun. Turn back to page 1, & start over with different pens, different angles, different purposes. Observe, borrow, copy, and combine—and you will discover a new alphabet every day for the rest of your life.

1NIDE	\ /	Crux	80	Half Bracket	22	Ondine			
INDE.	X	Crystal	62	Half-Gothic	52	Ondine Caps	54 55	split Swash Overlap	5
	2 •	Cubes	63	Half-round Gothic	45	Open Box	104	splither spongy	94
Alchemy	71	Cut	103	Happybet	34	Open West	46		12
Alias I	72	Database	63	Hatching	14	Palmer	35	Spray	99
Alias 2	72	Dead Center	25	Heavy Caps	21	Papyrus Caps	84	Sprung	40 93
Alphabet Nouveau	8	Decoroman	58	Heavy Copper	21	Parasol	11	Squarecut	78
Ampersand	23	Delhight	90	Heavy Italic	25	Pencil Rough	73	Square Edge	78
Angular Italic	92	Detour	66	Heavyland	25	Pixel	110	Square Point	78
Antiquarr	83	Devious	104	Heavy Mono	105	Prince Arthur	61	Square Root	88
Apache	89	Diamond Jim	58	Herald	60	Print	35	Square stencil	10
Arched Italic	33	Double Cross	22	Heraldry	60	Pro Musica	100	Squarif	64
Aura	19	Doubledeco	67	Highland	66	Quartz	22	Stain'd Glass Gothic	
Aura Caps	19	Double Face	23	Holiday	7	Raised Roman	97	Stars and Stripes	11
Azteca	88	Double Gap Caps	89	Horizontal Hold	20	Recti-Gothic	52	Staves	58
Backslant	46	Double Helix	48	Houseplant	41	Refract	97	Stiffen	74
Backward Italic	30	Downlight	106	Tcelandic	90	Retract	76	Stringy	93
Bamboo	13	Downlight 3/4 Right	107	Interruptus	64	Retread	48	Sunburst	16
Banco	76	Downside-up	101	Italic Caps	17	Reverb	100	Superceltic	15
Banded	89	Dry Brush	13	Jerusalem	42	Robot	92	Super Stencil	27
Banners	777	Dryland	11	Jolted	92	Roman	6	Swash Capitals	98
Basic Block	38	Dürer Caps	82	King Arthur	60	Ronde	51	Swash Italic	18
Basic Gothic	20	East Side	28	Lag B'omer	42	Ronde Caps	60	Swing	30
Basic Italic	36	Eastern Capitals	28	Leftbook	70	Rough Draft	37	Swingtime Caps	55
Beady	16	Echo	80	Left Italic	70	Runes	26	swish	55
Benedictus	95	Edelweiss	41	Legende	42	Russian	90	Taliesin	97
Big Kid	35	Embellished Gothic	109	Legende Caps	54	Rustica	46	Tall Book	84
Blister	22	Endless	66	Letter Box	6	Sabra	43	Thai-Hand	68
Blot	81	Endüre	82	Lettersweater	71	Scroll Gothic	108	Thistle	91
Bookhand	74	Enviro	8	Lightgothic	53	Scroll Square	52	3-D	40 97
Bookitalic	74	Esquire	60	Light Italic	29	self Center	73	3½-D	79
Booklet	15	Extra-lean Italic	30	Lightland	105	Shade	15	Tiffany	50
Booklight	36	Extra Light	33	Light Roman	9	Shalom	43	Truncate	96
Bookpush	68	Faceted	53	Light Split Italic	57	shamrock	26	Turned Celtic	31
Bookscroll	75	Fancyletters	34	Light Uncial	85	Shamrock Cap	27	Twinings	95
Bookshelf	77	Fast Forward	36	Lightning	81	shattered	32	2½-D	99
Bracketed	81	Fat Caps	25	Lights Out	33	Shimmery	94	Two-Ply	23
Breezy Uncials	55	Fat Mono	65	Lightweight Mono	16	Shimmey	102	Typewriter	62
Brush Italic	103	Fat Shadow	24	Liquid Crystal	98	Shivered	94	Typewriter Caps	62
Bubble!	44	Fat Unc	26	Lit-up	76	Short Cuts	79	United States	58
Bubbled	67	Fattest Mono	24	Little Kid	34	sidelight	106	Untogether	100
Bubbly	64	Fine Italian Hand	37	Loopy	50	Sidelighted	85	Uplight	106
Camellia	19	First Impressions	75	Lower Kingdom	12	Sidelined	89	Uplight 1/4 Left	33
Caroling	36	Flat Block	84	Magdalene	82	Skate Swash	84	Uplight 1/4 Right	107
Carpetbags	47	Flat Bookserif	38	Marquee	99	Skated Split Swash	64	Upper Kingdom	91
Cathedral	102	Flat Gothic	8	Masquerades	48	Skinny Gothic	109	Upright Italic	56
Celtic Any Case	7	Flat Light	106	Massmail	62	skinny Italic	46	Upright Italics	7
Celtic Light Face	26	Fleur de Lis	61	Mazel Tov	42	Slit Personality	81	Upside-Down	101
Chancellaresca	47	Flora	41	Mended	32	Smallsquare	59	Uptight Italic	56
Chip Off The Old Block		Florentine	83	Mesh	76	Snow	108	Valentine's Day	19
Chip-Off Serif	69	Flower Box	41	Minimal Monoline	103	Soft Center	73	Versals	109
Coiltic	17	Fraktur	44	Minimalist	100	Solid 3-D	71	Very Light Mono	105
Concave Gothic	45	Fraktur Capitals	44	Miscellaneous Grab Bag	11	Splats	71	Vivaldi	29
Concave Scroll	44	Frills	82	Moneon	99	Split Block	69	Vivaldi Caps	29
Context Convex Gothic	74	Glistered	8	Monoblock	39	Split Booklight	57	Waity	12
	94	Gothic Caps	52	Monodeco	38	Split Italic Au Naturel	56	Weathered	15
Copper Brush	12	Gothic Highlight	9	Monoitalic	16	split Italic Touched Up	56	Weirdness	92
Copper Caps	86	Gothic Initials	109	Monoline Book	38	split Italic Caps	29	wideland	78
Copperleaning Copper Loops	87	Gothic Lowlight	96	Monoline Serif	39	split-off	69	Wild West	20
Copperplate	87 86	Gothic Softlight Greek	30	Namor	10	split-Offserif	69	X-Chromosome	49
Copperstraight	87	Groundfog	90		105	split Ronde	50	Y-Chromosome	49
Copperwire	87	Ground Shadow	14 15	New Yorker	20	split Ronde Caps	50	Yeoman	31
		C. Cana Stadovy	13	Old West	103	Split Swash	18	Zap!	59

for Pleasure and Profit

designed for the beginning or intermediate calligrapher who needs practical advice. This book contains two dozen lettering projects, numerous how-to' illustrations, and over a hundred examples of finished

designs as an idea source—plus 800 monograms for every combination of initials. In addition, the materials required are inexpensive & readily available in local shops.

Beautiful designs and ingenious production, however, are not all that this book has to offer. Each chapter is full of short, useful business tips—50 in all—and includes one long section analyzing in depth answers to some common problems the freelance calligrapher will encounter. Whether you want to expand your lettering into a business or simply bring your hobby up to professional quality, you'll benefit from the author's years of experience freelancing, teaching, and conducting calligraphy workshops.

calligraphy projects charts the pitfalls, milestones, shortcuts, and goals. From its opening bookplate to its final colophon and traditional scribe's malediction, it will guide your pen by enlightening your eye.